FOOD & LIFE

© 2014 Assouline Publishing
601 West 26th Street, 18th floor
New York, NY 10001, USA
Tel.: 212-989-6769 Fax: 212-647-0005
www.assouline.com

ISBN: 9781614282648

Design by Camille Dubois.
All photographs © Harald Gottschalk.
Text and recipes translated from the French by Robin Bellinger.

Joël Robuchon
Dr. Nadia Volf

FOOD & LIFE

ASSOULINE

TABLE OF CONTENTS

CHAPTER 4
FOOD AND CLIMATE

CHAPTER 5
CELEBRATORY DISHES

ACKNOWLEDGMENTS

ABOUT THE AUTHORS & CREDITS

FOREWORD WHY?

By Joël Robuchon

When you know the happiness of finally living out childhood dreams; when you enjoy the tremendous satisfaction of finally mastering your craft; when your peers themselves trumpet your virtuosity, and the students you have molded fulfill their own promise—you might think that life has no more surprises in store. And then you realize that you never really stop learning, and that the perfection you had thought to be finally within grasp after years of unremitting work will always be just out of reach.

New challenges present themselves. Starting with the questioning of those certainties that have immutably piled up over the years, some of them adopted too quickly. You relearn how to listen and observe, you have fun ceaselessly indulging a rediscovered curiosity, you gather new knowledge that often illuminates the old.

This is where I was when I met Nadia Volf, a professor of medicine specializing in acupuncture. She led me to a true revelation: For more than forty years I had been trying to work magic in the preparation and pairing of foodstuffs, when all along they were first and foremost the source of life. Well chosen, they could become formidable therapeutic agents. How had I never thought of this? Certainly, in all my restaurants across the globe, I saw most guests leave with delighted expressions, satisfied bodies, smiling faces. But in a flash I realized that what I had always taken for formal courtesy and ad hoc thanks were in reality expressions of sincere gratitude. In organizing their menus, my guests were, without knowing it, listening to their bodies' needs, the demand for this or that vitamin, this or that molecule. And they had fed themselves well-being.

For me, this was a true revelation. And so I proposed this four-hands book to Nadia: She has chosen the ingredients and described their qualities and applications, while I have "set them to music" by creating new recipes and modifying certain old ones. Above all, I learned to reconsider my cooking in the light of this new knowledge, even though it meant shaking up my *idées reçues* quite a bit.

Thus I learned from Nadia that liver is excellent for health: It is in fact rich in antioxidants, very effective against arteriosclerosis (cholesterol plaque deposits inside arterial walls, which reduce the arteries' diameter and thereby restrict blood flow). According to Nadia, liver is one of the best foods for antioxidant supply.

The best foods are sometimes the simplest and most everyday. Thus chicken broth can work wonders in winter, when the bundled-up body retains water. And it is even better if this broth—fresh, needless to say, not out of a box or can—contains ginger, celery, garlic, and black peppercorns. Now, what is simpler to make?

I have often asked myself why and how turkey managed to supplant all other dishes on the Christmas table. Here again, it is Nadia who enlightened me, giving me an explanation at once scientific and perfectly logical: This bird is rich in an amino acid, tryptophan, which is the precursor of the hormone serotonin, which, in our nervous system, is responsible for... the sensation of joie de vivre! What better dish for Christmas?

Today, I have a different way of looking at my recipes and my craft. For more than forty years, I have been passionate about treating my guests. Today, my pleasure is doubled: I know that I am also taking care of their health. And I am fulfilled.

INTRODUCTION

THE ART OF NOURISHMENT

By Dr. Nadia Volf

In 1942, during the siege of Leningrad, Dmitri Shostakovich, in Siberian exile, completed his seventh symphony, today considered his masterpiece. He dedicated it to the city of his birth and to his embattled fellow citizens. The evening of August 9, despite famine and hardship, an immense crowd converged at the Philharmonic in the center of the city, coming on foot from all quarters and neighborhoods to hear the master's latest work. Most of the musicians of the Radio Orchestra had been mobilized, so to make up the hundred or so players required,

instrumentalists were recruited from the various bands of the Red Army to join in. The orchestra, directed by Carl Eliasberg, played for close to three hours. And this audience, which no doubt included many neophytes, made the show a real triumph. For three hours, they forgot war, hunger, suffering, despair, and even horror.

All our life is thus exalted by the magic power of art— art that bears us off into dreams, allows us to touch everyday beauties, insists unceasingly on the simple happiness of existing, and wakes in us infinite, previously unimagined possibilities—art whose near-universal power can cure the soul's ills, but can also help to treat our bodies. A few days after the August 9 concert, it was even rumored that a

number of babushkas—that is, grandmothers—had begun again to produce a bit of milk to contribute to the nourishment of their grandchildren.

If we were not susceptible to art, would we be susceptible to love?

The magic of art sharpens our intuition, our perception of the world, of events, of natural phenomena, multiplies our capacities and our talents, and enchants our everyday life.

For each of our five senses, man has felt the need to create an art:

→ **For the eye and vision**, pictorial art (drawing, painting, photography) and assembling these images to invent cinema;

→ **For the ear and hearing**, music, orchestral or lyrical, and even poetry, which is the music of words;

→ **For the nose and smell**, the art of perfumery;

→ **For the hand and touch**, sculpture;

→ **For the taste buds and taste**, cookery, the art of preparing and putting together the foods offered by nature.

This book was born of my passion for culinary art, or more precisely of my love of life, this life of which food is the true source.

It was born, too, of a doctor and a great chef's shared revolt against the absurdity of certain contemporary eating habits. Nobody has ever tried to cure vision by closing the eyes, nor deafness by sealing the ears. But that's what more and more fashionable "diets" demand: that one deprive oneself of food as if it is all destined to turn into flab. In the sixteenth century, Paracelsus wrote it: "The dose makes the poison." By thus confusing a thing with an excess of that thing, we create deficiencies, imperil our health, and deprive ourselves of a good part of the joy of living.

This book is a hymn to food! To the art of cuisine! A delicious art, beneficial for health, for well-being, and for all that is a source of life.

How I became passionate about cuisine:

For part of my life, I didn't pay any attention to food. At medical school and later at the hospital where I practiced, I was always very hard at work, and I never really had time for regular meals: I nibbled a sandwich during a break or devoured chocolate before a test.

Having gained some weight on this "survival diet," I undertook a three-month reducing regime on which I ate only apples and a bit of cheese. Today, with hindsight, I find it unbelievable that I so neglected the most basic rules of nourishment. Nevertheless, I lost twenty or so kilos in a short time, and I was very pleased. Happily, acupuncture, which I was already practicing on myself, kept me in shape and protected me from the health problems associated with deficiencies.

And then one day a family friend invited my husband and me to dine at Joël Robuchon's restaurant after work. My first instinct was to decline the invitation in order "not to lose time," but my husband really wanted to go. And so we found ourselves at L'Atelier de Joël Robuchon on the Champs-Élysées. The chef with more Michelin stars than any other in the world had created a very original formula and had reproduced it several of the world's great cities: The kitchen is in the middle of the room, framed on all sides by a square of counters.

Exhausted after a day of intense work, I watched the ballet of the cooks and their helpers, all dressed in black. For the first time, I saw cuisine from the inside: Before my eyes, like actors in a play, the apprentices peeled potatoes, the young chefs prepared dishes and then decorated them like true works of art, precisely adjusting grains and morsels of fruit around the edge of each plate. Like musicians in an orchestra, their movements were organized, coordinated, and directed by a chef.

I tasted these dishes, and my body, my heart, and my spirit shivered in unison, in a wave of pleasure and warmth. Until then, I had only had this sensation at the opera, when the soprano or the tenor burst into song. All at once, I realized the importance of food, and understood that cuisine is a true art when it captivates the body and spirit this way. I immediately felt immense gratitude, and also real admiration for this chef who knew how to orchestrate flavors so marvelously. Thus was born our friendship with Joël Robuchon, crowned Chef of the Century by the Gault-Millau.

This book, the fruit of that friendship, has just one goal: to put the art of cuisine at the service of well-being.

10

THIS BOOK HAS FIVE PARTS

 THE MAGIC OF FOODS
The beneficial virtues of fruit and vegetable juices, broths, and everyday foods. With, for each one, recipes for dishes and concoctions as delicious as they are good for you.

 NOURISHING LIFE:
FOODS THAT PREVENT AND FOODS THAT CURE
What you need to know to be long-lived and in good shape: balanced gourmet recipes for all seasons, all weathers (cold, hot, rain, wind), and all stages of life.

 THE VIRTUOSITY OF THE MAGICIAN
The farmer and the rancher offer products, the cook chooses them for their qualities, and presents them to complement one another, always endeavoring to respect their identities.

 FOOD AND CLIMATE: SEASONAL DISHES
Depending on whether it is hot or cold, dry or humid, whether the nights are growing shorter or longer, the body needs different things to find balance. Salade niçoise and stew are both full of vegetables, but one doesn't crave them at the same time.

CELEBRATORY DISHES: THE HAPPINESS OF LIVING
Often rare, therefore costly, but not necessarily harmful to health: Liver, very rich in iron and antioxidants, is in fact one of the best things one can eat.

CHAPTER 1
THE MAGIC OF FOODS

Each food is unique because it holds, in variable proportions and diverse forms, its own ingredients: minerals, vitamins, proteins, carbohydrates, and fats. Combined, these elements become a unique ensemble that transfigures the individual virtues of each foodstuff and allows it to best fulfill its essential mission: to nourish each of the body's cells, bringing them energy and all the elements necessary for life. It's a little like it is with a car: The fuel must be exactly right for the motor or it may break down.

To use an analogy from the realm of art, one might also compare food to a symphony orchestra: Each instrument contributes its own charm, but it is the ensemble, under the conductor's precise direction, that weaves the work and creates the magic. In the same way, each food provides its own tastes and physical properties, but it is their harmonious combination that makes the perfection of a dish: Gustatory perfection for maximum pleasure, but also dietetic perfection through the dish's beneficial effects on the body.

Not coincidentally, we French use the same word—*chef*—for the person who conducts an orchestra and the one who reigns over the kitchen.

FRUITS

POMEGRANATE JUICE

Throughout western and central Asia, celebratory tables are adorned with pomegranates, escorting the dishes like so many fireworks. Beyond cultural and religious tradition, this practice is very important physiologically because this fruit, with its apple shape and pretty red-orange color at ripeness (between September and December), contains a lot of iron.

And not just any iron, but the kind most easily absorbed by the body: It is picked up right in the stomach by blood cells. After the long months of winter, when we tend to lack strength, vital energy, vitamins, and minerals, pomegranate juice supplies the body with precious sap. It helps the body wake up after hibernation, bringing it a veritable elixir of youth.

PINEAPPLE JUICE

Pineapple juice contains bromelain, a powerful anti-inflammatory and analgesic substance. Another of its virtues is its power to satisfy. Although it is very low in calories, it has an almost unbelievable effect on the sense of fullness: Just a few glugs hold off hunger—a dream for anyone watching his or her figure. Perhaps this is related to another of its numerous virtues: Endowed with a strong anti-acidic power, it reduces heartburn.

SEA BUCKTHORN JUICE

Bunches of sea buckthorn fall from the tree in orange-tinted garlands, full of beneficial powers. With loads of vitamins A, E, and C, they are a true antioxidant treasure, protecting the blood vessels against arteriosclerotic plaque and repairing mucus membranes. Traditionally sea buckthorn juice or oil has been used to treat wounds and cuts small and large, and to strengthen mucus membranes.

GRAPEFRUIT JUICE

An elixir for the liver, it stimulates the secretion of bile and frees its passage. Combined with radish and artichoke juice, it makes a well-being cure for the liver and gallbladder. At the same time, it is an excellent drink to prepare muscles for exertion, protecting them from fatigue and cramps, and augmenting flexibility. Also to its credit, it balances blood sugar and staves off the fatigue associated with shortage of glucose during physical effort.

It is also an antidote to stress, neutralizing the exhaustion that seems insurmountable and that always arises after some significant or startling event. This kind of fatigue has to do with hypoglycemia, a dramatic lack of sugar, which the body has exhausted during the episode. Grapefruit not only corrects the situation but also, thanks to its abundance of vitamin C, restores energy and tone. Finally, in juice form, it also regularizes appetite, eases a sweet tooth, and helps prevent stress eating.

LEMON JUICE

A mischievous drink, its acidic taste hides its true virtue—a powerful alkalinity. In the stomach, when affected by gastric juices, lemon's acidity is transformed. From a medical standpoint, it is an excellent treatment for rheumatism and gout, the inflammation and swelling of the joints brought on by the stagnation of uric acid from red meat. (Gout has been called the disease of English lords, because traditionally they hunted and ate much game, causing an excess of uric acid.)

WATERMELON JUICE

Watermelon juice is an elixir for the kidneys. I remember that in Russia the government used to give vouchers for free watermelons to children with kidney problems. Watermelon juice is quenches thirst, excellent during high heat. It contains carbohydrates, lots of minerals, and most importantly water. Its hydrating and beneficial properties, good for the kidneys and the nervous and cardiovascular systems, make it an incomparable summer beverage.

CHERRY JUICE

The cherry is a treasure trove of calcium and phosphorus, indispensable for the construction and sturdiness of the skeletal system. What's more, it contains vitamin C, indispensable for optimal absorption of these minerals by the bones and the blood.

LINGONBERRY JUICE

The lingonberry is an extraordinary disinfectant for the urinary and intestinal systems, an effect increased by its capacity to drain. Traditionally it is also used to treat the female reproductive system: It encourages diuresis and femininity, maintains women's youth, and counteracts osteoporosis and water retention.

CRANBERRY JUICE

The cranberry is a great antioxidant. By preventing the reactions of free radicals in the body, it improves the functioning of the urinary and cardiovascular systems, holds off mental aging (even Alzheimer's disease), and neutralizes the acidity associated with gastritis. Scientific data indicate that it even plays a beneficial role in fighting certain cancers. Historically, sailors used cranberry to prevent scurvy, due to its high vitamin C content.

COMPOTE OF DRIED FRUITS

Dried fruits contain potassium and manganese, minerals necessary for the relaxation of the heart and blood vessels. In summer, when heat fatigues the cardiovascular system, a compote of dried fruits, combined with almonds, makes for a kind of "champagne for the heart." Almonds are a perfect ally, since they help invigorate and nourish the heart muscle.

BAKED APPLES

The pectin in apples is a variety of cellulose that is good for digestion: It absorbs toxins and gases, relaxes the intestines, and allays diarrhea. In France it is the first food given to babies other than milk: As early as six weeks, baked apples may be offered.

THE INDISPENSABLE JUICER

Just as fruit juices bring together the essences of fruits, vegetable juices make it possible to concentrate in a single drink all the vitamins, minerals, and nutrients found in a whole basket of vegetables. A single glass of carrot juice contains the vitamins and mineral salts of ten carrots, a bowl of cabbage juice those of a whole cabbage. This is why I believe the juicer is an essential kitchen appliance. (Fruits, vegetables, meats, or seafoods can also be boiled to extract their treasures.) Broths and compotes contain elements that benefit the body; their effects have long been known: Chicken broth can reestablish digestion, meat broth warms the body in winter.

VEGETABLES

SOYBEANS

In the West almost always used as oil or for livestock feed, soybeans are, on the other hand, well appreciated as **an everyday food by the Chinese, Japanese, and Koreans. The story of soy goes back to the fifth century in Southeast Asia,** but today the United States is the world's largest producer (more than a third of the total), ahead of Brazil and Argentina. India and China devote just as much of their cultivable land to soybeans, but they themselves are great consumers as well, to the point of needing to import.

Their taste is sweet, their pH (the "hydrogen potential," which measures acidity) about neutral, and their refreshing properties undeniable. They also contain all the essential amino acids. **Tofu, or soybean curd, contains an enzyme, nattokinase, which promotes the reduction of cholesterol.**

A good way to reduce cholesterol: Speed up the metabolism and digestive elimination (enzymes secreted by the liver turn cholesterol into bile). This can be accomplished by mixing soybeans with celery, adding olive oil, chestnuts, and black sesame seeds.

BEANS

In general, beans have an **invigorating effect on digestion,** and detoxifying properties that help to drain and reduce lymphatic swelling by promoting urination.

Already popular in Asia in 1000 BCE, adzuki beans—also called Japanese red beans—are rich in healthy qualities that made them an everyday food in the Far East. Rather sweet and extremely refreshing, they are generally served with rice. **It is, however, preferable to consume them as a soup or porridge.** Above all, to preserve their minerals (iron, calcium, zinc, copper), which are indispensable for the production of blood and bone, **you must soak the beans in water for eight hours before cooking them:** This diminishes levels of polyphenols and tannins that impede mineral absorption. Adzuki beans support blood production, and have been shown to be very effective against deficiencies when combined with brown sugar.

Red beans are great diuretics, excellent for dissipating warmth; they also make it easier to fall asleep, and are traditionally used to relieve urinary tract infections.

Green mung beans are recommended, especially to the elderly, in times of high heat: By encouraging perspiration, **they help the body cool itself.** This effect is equally welcome when treating fevers or infectious diseases.

Finally, butter beans help people cope with dizziness and ringing in the ears.

LENTILS

This protein-rich legume has an extraordinary quality that makes it irreplaceable in very hot times and places, or in cultures that favor very spicy foods: It promotes body hydration and facilitates the secretion of gastric juices. Lentils used to be prescribed during convalescence and after childbirth, or when someone had lost liquids, such as due to dehydration or bleeding. Always eaten cooked (but not too much), lentils pair perfectly with walnuts or coconut to make delicious salads.

GREEN PEAS

Green peas contain a high concentration of niacin, an active substance that helps to eliminate cholesterol and to resolve sluggish blood flow. Traditionally they were recommended to fight problems of circulation, edema, and water retention in the legs.

COWPEAS

Also called the black-eyed pea, very common in Africa, Latin America, and the southeastern United States, this kidney-shaped bean with its faintly sweet taste is often used in soups. Traditionally it is reputed to increase appetite and urination, ease abdominal distension, bloating and discomfort, and it checks vaginal secretions.

FAVA BEANS

These sweet-tasting beans have a warming property. Often recommended to fight loss of appetite, urinary problems, edema and water retention, they are also used to alleviate hemorrhoids and prolapse.

CHICKPEAS

Native to southeastern Turkey, where traces have been found dating to 3000 BCE, the chickpea came to Europe around the ninth century but did not arrive in India, today the world's chief producer, until the eighteenth.

From a dietetic standpoint, the chickpea evinces exceptional qualities: Endowed with a strong ability to satiate and a very low glycemic index, it is a favored ally of diabetics; very low in calories and fat, it is also beloved by dieters; it is also particularly rich in mineral salts (manganese, copper, phosphorus, iron, zinc, magnesium, potassium, selenium) and notably in molybdenum, as rare in nature as it is precious for the human body, where it eases the elimination of uric acid and thereby fights

gout. Incidentally the chickpea is often found in old British cookbooks: His Majesty's lords, great consumers of the game they hunted, were partial to chickpeas to hold off joint pain.

The chickpea has plenty of other fine qualities: In the digestive system, it has a deworming effect, helping to eliminate parasites and to encourage good intestinal flora (bifidobacteria), which themselves protect against infections and allergies. Its high quantities of B vitamins do much for the good healthy of the skin. And its richness in tryptophan, an amino acid used by the nervous system to make serotonin and melatonin, helps fight depressive states, loss of appetite, and irregular sleep.

CARROT JUICE

Carrot juice is an immense reservoir of vitamin A, a powerful antioxidant indispensable for the quality of vision. During times of famine in Russia in the twentieth century, many relatively young people gradually succumbed to blindness on account of vitamin A deficiency. A bunch of carrots was therefore a most appreciated gift, because it was rather like being offered sight itself.

Carrot juice is also an excellent antidote to the harmful effects of toxins and heavy metals. During the 1960s, my mother, also a doctor and professor of medicine, used carrot juice to prevent certain occupational illnesses of Russian factory workers. These illnesses, very common at the time, were associated with the heavy use of toxic materials, which encouraged the production of free radicals in the body and harmed cardiovascular health. The simple act of giving factory workers a free daily glass of carrot juice significantly diminished these illnesses.

GREEN CABBAGE JUICE

Green cabbage is the best natural antacid. It contains vitamin U, a great antidote to acidity. Just a bit of cabbage juice relieves heartburn and protects the gums and the digestive system from acids. After a night of drinking, when alcohol irritates the stomach's mucus membranes and causes a certain state of fatigue associated with acidosis, a glass of cabbage juice reestablishes proper body function and neutralizes the effects of excess.

An infusion of salty pickles has the same effect. In Russia, this is part of the hangover tradition.

Potato juice, which also has a strong alkaline and antacid property, is often recommended for stomach problems.

Add turmeric, which neutralizes fermentation and gas formation, and the mixture's beneficial effect is comparable to a Beethoven lullaby.

BEET JUICE

Beet juice contains a lot of mineral salts, especially iron and sulfur, indispensable for good intestinal digestion. **It boosts the intestines' function, protects them from inflammation, and facilitates the elimination of waste.** If you add a juice or infusion of prunes, which have the same effect, you have a strong beneficial cocktail for the intestines.

BROTHS

Broth is an extract, a way of accessing the essence of meat, fish, seafood, or mushrooms. To absorb it well requires no digestive effort: The nutrients and minerals it contains in great quantities enter the blood directly through the walls of the stomach and small intestine. For this reason, broths were traditionally used as first foods for babies, and also for convalescents and patients with digestive difficulties.

CHICKEN BROTH

Pediatricians in France have long recommended giving chicken broth to babies from six months on, before offering the first solid foods. The intention is obvious: Chicken broth stimulates gastric secretions necessary for good digestion. There is no better food for bolstering health after sickness or surgical intervention, for digestion is the body's essential source of energy. This particular broth aids absorption of fuel. Adding a bit of ginger, which also stimulates gastric secretions, improves the quality of digestion and augments appetite. Thus the alimentary concerto is perfected.

BEEF BROTH

It wasn't so long ago that, in all the countries of Europe and the East, when the thermometer itself would shiver, one would offer visitors dropping in or hunters returning from a long day a big bowl of beef broth to help them regain strength. Rich in iron, proteins, and fat, it warms the body, activates digestion, and quickly restores a feeling of energy.

GRAINS

Grains are universal foods. They nourish and contain everything a body (a bird's as well as a human's) needs to live: complete proteins, essential amino acids, carbohydrates, and fats. All whole grains contain calcium and phosphorus, necessary for bone structure. Phosphorus also helps convert sugars to phosphates and is thus a real stock of energy. Grains also contain B vitamins (B1 and B2), and niacin, our essential weapon against excess cholesterol.

Grains may be served in a variety of ways: on their own, as a side dish, in salads, as porridge, and more. Traditionally, they had their place at breakfast thanks to their potential energy, richness in proteins and minerals, and their power to satisfy. They are an ideal preparation for the efforts demanded by a new day, whether physical or intellectual. Finally, they can be paired with most other foods: meat, fish, seafood, fruits, mushrooms, vegetables. They can even be toasted and steeped as an infusion. The old traditions never separate physical functions from emotional context, and so each cereal also exerts a certain influence on our emotions.

CORN

Struck by the way it reaches up, the ancients often said that corn "raises us toward the sky." It is true that it helped humans to evolve and to develop our intelligence and liveliness. Sweet in the mouth and somewhat neutral tasting, it contains easily digested carbohydrates that provide quick energy. Finely ground corn, such as polenta or grits, contributes to the reduction of edemas and lymphatic congestion. It is also useful in reducing blood pressure. Corn also contains active substances such as quercetin, a flavonoid beneficial to the blood vessels and against allergies, and which helps prevent urinary tract infections. Finally, it strengthens the constitution.

BARLEY

According to old wisdom, barley helps to lighten the spirit and to better see essential goals of life. (Perhaps this impression led to the invention of scotch whiskey.) It is twice as rich in fiber as are oats, and therefore is an effective ally against cholesterol. Barley marries sweet and savory flavors. From a physiological standpoint, it has a strong draining power, which combats water retention and prevents cystitis. It is said to have antifungal properties that cure plantar warts. It is particularly beneficial

for children with digestive difficulties. However, in the case of breastfeeding, it halts the mother's milk production, which may also be a desired effect at times.

MILLET

In the West, it is mostly used for birdseed, but it is very popular in northern China, and in India it remains one of the principal grains. Like barley, its taste is at once sweet and savory. Millet's principal virtue is to bring freshness, very pleasant during hot weather. It has often been used to fight inflammatory conditions (hepatitis, pancreatitis, inflammations of the internal organs, the intestines, and urinary tracts in particular). Historically, it was always mixed with other grains—often barley and corn—as well as with various nuts.

SORGHUM

Very popular in northern China, sorghum's slightly astringent flavor excites the taste buds. Above all, it has the capacity to warm the body, a precious thing in climates that tend to be cold. It was traditionally recognized for its capacity to stop loss of liquids: diarrhea, frequent urination, excessive perspiration. Because it reinforces the blood vessels, sorghum is also good for the elderly. Finally, rich in iron, it prevents anemia.

BUCKWHEAT (RUSSIAN KASHA)

Among grains it is one of the richest in proteins, a veritable fuel that has always been used to gather strength before taking on difficult physical labor. Buckwheat is effective at stopping nausea, vomiting, and burping, for resolving alimentary stagnation and facilitating complete digestion. It contains rutin, which helps to reduce cholesterol levels, stabilize blood pressure, and strengthen blood vessel walls. In addition, it soothes irritations of the mucus membranes, and it is traditionally used to fight allergies, sinusitis, and venereal infections. And on extremely hot days, it produces a very welcome sensation of coolness.

AMARANTH (CHINESE SPINACH)

This was a grain so important for the Aztecs that they often used it in their religious ceremonies. When the Spanish conquered them, one of the invaders' first decisions was predictably enough to forbid its cultivation, to the point that it nearly disappeared from the planet. We are just now beginning to rediscover this protein-rich grain, loaded also with nitrates, which means it is not recommended for children. On the other hand, it contains lysine, effective when treating afflictions of the skin (breakouts, acne, herpes) and migraines.

OATS

Oats are a sticky grain, sweet and refreshing. They are particularly associated with Ireland and Scotland, and were not used in China until the twentieth century. Traditionally, oats were steamed and then flattened by a roller. Very soothing for the intestines' mucus

membranes, oats also promote peristalsis. They are especially good for children with a certain intestinal delicacy, distension, and gas. Finally, they are also remarkable for their filling quality.

RYE

Rye was very popular in seventeenth-century colonial America. According to certain sources, it may have even figured indirectly at the root of the Salem witch trials: a parasitic fungus, rye ergot, contains alkaloids similar to LSD. Today, certain neuroactive substances are extracted from rye to treat mental illnesses. **Its rather high fiber content makes it tolerable for diabetics despite its sweet taste.** It also promotes peristalsis. Useful in stopping too-frequent urination and bleeding, rye bread must be systematically paired with fruits.

QUINOA

Considered to be a pseudo-grain, as it is not a grass, quinoa has been cultivated for more than 5,000 years in the highlands of South America. Very rich in iron, it contains complete proteins and all the essential amino acids, but its flour is not suitable for making bread (possibly explaining why it failed to catch the attention of the Spanish conquistadors). Not sticky, sweet in the mouth, warm, it is a **great supplier of energy**. Finally, it is quite effective in confronting feeble digestion, loss of appetite, diarrhea, abdominal distension, or gas.

WHEAT

Sweet-tasting wheat is also cooling: It used to be recommended to combat night sweats, for example, during the hot flashes associated with menopause. In addition, it soothes the spirit and emotions and promotes sleep.

RICE

Of all the grains, rice is the easiest to digest: Traditionally it is often the first solid food offered to babies. Very good at improving digestion and fighting loss of appetite, it is also recommended to stop vomiting and diarrhea. But its effects strictly depend on the type chosen, the way it is prepared, and the dishes it accompanies. Thus sticky rice, very popular in Laos and northeastern Thailand, is very effective against excess sweating and for recovery after loss of blood and liquid in childbirth, especially when served with meat, beets, or dates. Wild rice is very rich in fiber and protein but rather lacking in calcium and iron. Black rice has calming effects that help control nightmares, and it is also excellent at fighting bed-wetting in young children.

TEFF

Mainly cultivated in the highlands of Eritrea and Ethiopia, teff is a grain whose tiny seeds have warming properties. It is an excellent diuretic, promoting draining and urination, and it contains no gluten.

NUTS

Nuts—walnuts, hazelnuts, almonds, pine nuts, Brazil nuts, coconuts, macadamias, pecans—were once prescribed for cultivating the human virtues. It was even said that they dispelled negative emotions such as guilt, contempt, vanity, and so on. It is true that thanks to their calming and tranquilizing effect they bring a bit of serenity into everyday life, and are particularly indicated in certain circumstances, such as a lasting depression. Many of these nuts, rather numerous in nature and often found in breakfast muesli, also do good things for the blood. Brazil nuts, also called Amazon nuts, contain folic acid, which promotes the blood's absorption of iron.

ALMONDS

Almonds have a happy effect on the respiratory system, to such an extent that they were traditionally recommended for coughing and wheezing. From a more psychological standpoint, they were prescribed for coping with bereavement, grief, or sadness—also, more surprisingly, for helping people find the strength to forgive. Finally, almonds contain amygdalin, which helps to regulate appetite and promote libido.

PINE NUTS

The pine nut is a symbol of longevity in Chinese culture: According to the oldest legends, the immortals ate only pine nuts, which provided them with all the energy necessary for life. This little nut, also very effective against coughing and wheezing, treats pains and inflammations, difficult digestion, and has very good effects on the blood as well as on feelings of sadness or sorrow.

WALNUTS

The shelled walnut is strangely evocative of the human brain and its two halves, with its convolutions and folds, yet it reveals itself to be effective for lumbago and joint problems, such as in the knees. In a decoction, it is reputed to dissolve kidney stones; prepared the same way, its shell is useful for relieving hernias. Toasted, they were once recommended for treating infertility and impotence, stopping too-frequent urination, and soothing inflammation of the prostate. Finally, walnut oil effectively treats eczema and dermatitis.

CHESTNUTS

Chestnuts contain high quantities of enzymes that create an astringency and help to digest fats. Like other nuts, they have very beneficial effects against too-frequent urination, infertility, and throat irritation. Additionally, they are reputed to stop hemorrhage.

PEANUTS

This legume is consumed in a variety of forms: oil, butter, margarine, flour, puree, shelled and salted with drinks, as animal feed, and is even used as industrial oil (for example, in soap production). Its flower's name means "a new start," that which creates metamorphosis and promotes change. Paired with meat and pork, eggs, ginger, and vinegar, peanuts have been recommended to women after childbirth to promote nursing and milk flow. They also improve appetite and thin mucus, facilitating expectoration and breathing. Finally, they are reputedly very effective at stopping bleeding, and were often prescribed to hemophiliacs because they speed coagulation.

PISTACHIOS

Pistachios contain lutein, which seems able to prevent age-related macular degeneration. Certainly they have a very good effect on the heart, helping to maintain blood pressure and lower cholesterol. As a powder or plaster, they improve circulation and treat varicose veins. They are also very effective at reducing fear or simple apprehension, and may be recommended before a test, competition, or job interview.

CASHEWS

Called in Greek *anacardium,* the cashew in effect treats all problems in the heart or core area of the body, from lumbar pain to intestinal problems. It is also good for the ears, and it was once recommended to treat buzzing and hearing problems. Powdered and diluted in alcohol, cashews are used to relieve lumbago and knee pain.

MACADAMIA NUTS

Largely cultivated in Australia, New Zealand, South Africa, and in Brazil, the macadamia nut is remarkable for its high quantities of monounsaturated fats (such as palmitoleic acid), indispensable for the integrity of the mucus membranes of the respiratory passages and for keeping them moist. Its taste is sweet, and its refreshing properties must be appreciated during heat waves. Traditionally, it was used to promote fertility. Today, it is frequently used in cosmetics. Powdered, it is a very effective treatment for psoriasis. In the form of massage oil, it is powerfully relaxing and, as a "dry" oil, which penetrates deeply, it has the huge benefit of leaving no greasy traces on the skin.

BRAZIL NUTS

Growing in the forests of the Amazon at the top of a gigantic tree (100 feet high, with oval leaves that can be two feet long), the fruit of the Brazil nut tree has three successive shells: In the first, the size of a large melon, are 20 to 25 seeds, each of which contains about 15 proper nuts, each about two inches long. Rather sweet tasting, the Brazil nut is rich in folic acid (vitamin B9) and in B vitamins in general, and has one of the highest saturated fat contents. Traditionally used for good brain function and to improve the blood, it was also recommended in times past to diminish swelling of the breasts and the prostate.

HAZELNUTS

Squirrels know well that the hazelnut has many fine qualities: Sweet and refreshing, it fights fatigue, sleepiness, and muscular weakness, promotes diuresis, encourages appetite, calms aggression, and wipes out irritability. What squirrels surely do not know is that, powdered and applied topically, it helps relieve swelling and anal fistulas. Also, Italian researchers recently discovered that hazelnuts contain a substance similar to taxol, a chemotherapeutic agent used to treat breast cancer.

COCONUTS

Although not a true nut, coconuts are sweet tasting and very refreshing, and contain magnesium, amino acids, and selenium. Traditionally used to treat symptoms of anemia, pallor, fatigue, fragile nails and hair, and difficulty falling asleep, coconuts are also a powerful source of electrolytes, necessary for staving off excessive dryness of the skin and eyes. Good to know: Brewed, the coconut's green husk makes a delicious beverage that dispels summer heat and promotes perspiration.

Apples, raisins, and walnut crumble, recipe on page 56.

SEAFOOD

Shellfish, like seeds and nuts, have for ages been considered important foods for aiding comprehension of the meaning of life. Rich in calcium, they have a genuine effect on the constitution and the body's capacity for regeneration, especially when bone problems such as osteoporosis arise, or chronic skin problems like psoriasis, eczema, or scleroderma. Popularly reputed to have aphrodisiac qualities, seafood truly does affect the hormones, and is effective against infertility.

Rock lobsters (langoustes) and mussels contain great quantities of omega-3 (polyunsaturated fatty acids), known primarily for its protective effects on the cardio-vascular system, somewhat less for its effects on vision, memory, and depressive tendencies. Rock lobsters and mussels also have anti-inflammatory properties, particularly beneficial for treating asthma and inflammation of the joints or the digestive passages.

Rich in proteins and minerals, like all crustaceans, crab is especially exceptional for its zinc content, extremely important for good brain function including memory, concentration, and sense of orientation.

Seeds have always been reputed to be beneficial in controlling spiritual and emotional states, and consequently the way they are expressed, perhaps because they have beneficial effects on the body itself, stimulating the intestines and promoting cleansing. For a long time, it was said that seeds have a positive influence on psychology, helping people accept undesirable situations. Good to know: To regenerate dried seeds, and thus to strengthen their effects, soak them in water for a few hours before eating or cooking them.

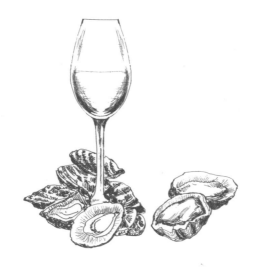

SEEDS

PUMPKIN SEEDS
Pumpkin seeds are reputed to help mental activity, especially to fight obsession and exhaustion. Mixed with honey, they effectively get rid of intestinal parasites.

SUNFLOWER SEEDS
Traditionally, sunflower seeds were used after excessive physical labor to combat muscular fatigue, lack of oxygen, muscle cramps, and so on.

SESAME SEEDS
Sesame seeds are the queens of their category, useful for renal problems, overwork, and fatigue in general, whether physical, emotional, or mental.

FLAX SEEDS
Formerly, flax seeds were recommended to people who were a little agitated or aggressive: In effect, they promote the acceptance of emotions and relaxation. Useful in the prevention of premature aging and neurologic diseases, they also have a laxative effect, promoting elimination.

POPPY SEEDS
Poppy seeds contain natural opioids, calming the spirit and promote sleep—an excellent natural antidepressant.

HEMP, CHIA, AND LOTUS SEEDS
These were traditionally used for problems associated with the heart, with emotional stress, and with language. In effect, they help with the expression of feelings, speaking without fear, and overcoming emotional stress.

THE CULINARY STRATEGY

The art of cuisine consists of combining foods, exactly as one assembles notes or words to write a symphony or a poem.

True culinary poetry, however, takes up a double challenge: to marry foods harmoniously and in a complementary fashion not only with respect to their individual flavors but also in accordance with their dietetic effects. The strategy consists of choosing and then assembling on the plate an effective team: a principal food, a partner, a supporting player, and a guest.

THE PRINCIPAL FOOD is clearly the first selection criterion: One feels like (or senses the need for) fish, chicken, red meat, vegetables, fruits, grains, seeds, or nuts.

THE PARTNER FOOD has the same function as the principal. For example, one may pair seeds with fish.

THE SUPPORTING FOOD must promote the gustatory engagement and elimination of the two first choices. In the above case, fish and seeds, one would add mollusks (not crustaceans), which would facilitate the digestion of the principal and partner foods.

THE GUEST FOOD inflects the dish's tendencies by heightening its flavors (pepper, for instance, is a formidable taste enhancer) and also by amplifying its dietetic effects: It must, for instance, produce a warming impression when one is cold, or, on the contrary, refreshment when one is hot. The guest food must invigorate when it meets fatigue, and promote relaxation when it encounters stress. It is also the guest food that must signal satiety when our eyes are bigger than our stomachs, or, on the contrary, stimulate a sluggish appetite.

➡ *For example:*

Principal food: sea scallops

Partner food: spinach, whose light bitterness can either attract or repel certain eaters (notably children); green beans or haricots verts; black sesame seeds

Supporting food: a bit of cognac or sloe liqueur, since alcohol stimulates the production of gastric juices, which will help to better digest the scallops

Guest food: cabbage, or fruits that, as contrasts, will heighten the tastes of the vegetables and grains.

Quickly sauté the scallops and spinach, sprinkle with black sesame seeds, and add a fruit coulis (apricot sauce, for example), cognac or sloe liqueur.

This is a recipe to offer a convalescent or someone feeling fatigued, for it will help them regain energy.

CHAPTER 2
FOODS THAT PREVENT AND FOODS THAT CURE

Food is ever-present in our lives. Several times a day, the same question comes up: *What do I feel like eating now?* Or, often vaguely sensed without being truly expressed: *What does my body need at this moment?* The answer is always different, depending on various interconnected factors.

There is, first of all, our mood: Enthusiastic or grouchy, joyful or lousy, the appetite is not the same. But our mood is also closely tied to the weather: Under a beaming sun or a rain-heavy gray sky, in torrid heat or Siberian cold, you feel either more or less like feeding yourself, and obviously not the same things. This mood further depends upon an infinity of everyday variables:

Money worries, health problems, tests to take or competitions to prepare for, anxiety about the near or far future, family tensions or concerns about loved ones.

And then there is age. Whether we like it or not, and notwithstanding the progress made over the years regarding life expectancy, the body reminds us from time to time of its deterioration, its deficiencies, its nutrient needs, and also of what it cannot tolerate, often the price of our past excesses.

We are constantly adapting to the people and world around us, often an exhausting proposition. At the same time, the act of feeding oneself can be an extraordinary pleasure, thanks to that marvelous human invention, gastronomy. There is no true celebration without tasty treats, no true recovery without menus adapted and presented so as to whet the appetite, no sports record or academic triumph without serious dietary preparation.

The pleasures of the table beget a sense of fullness, cultivate joie de vivre, and provide serenity. One notes that in life's most difficult moments, the first instinct is often to turn to food: The baby demands the breast, a treat ameliorates a child's suffering, Russian poets sought comfort in frenzied banquets. From a scientific point of view, it is easy to explain this phenomenon: Food, and the anticipation of gustatory pleasure, causes the secretion of active substances in the stomach, in the nerve centers, and even in the heart (internal opioids). This greatly promotes good mood, euphoria, joie de vivre, and even a mild sensation of intoxication and happiness.

Thus all forms of art come together at the physiological level, thanks to this extraordinary action in the human body that grips the heart and the nerve centers at the same time. The intense pleasure given by music, opera, poetry, painting, or gastronomy always follows the same progression. (The same, incidentally, that leads to orgasm.)

FOOD AND EMOTIONS
This research is based on linking emotions with their corresponding foods and flavors, in order to help us control them—to not only release emotions but also to free ourselves from being overwhelmed by them.

✱ Five flavors that help manage the five main emotions:

Spicy: helps to reduce and control anger
Salty: helps to decrease anxiety
Bitter: can ease pain and sadness
Sweet: reduces fear
Sour: helps the body accept change

The following recipe combines these five flavors in one dish: The cabbage supplies acidity; ginger, spice; potatoes, sweetness; coriander, bitterness; and soy milk, saltiness.

INDIAN SOUP

SERVES 4

12 oz (350 g) cauliflower, cut into florets
4 medium onions, peeled and sliced thin
½ oz (15 g) fresh ginger, peeled and sliced thin
12 oz (350 g) potatoes, peeled, diced small
6 cloves garlic, chopped in half, degermed
1 Tbsp olive oil
1 tsp turmeric

2 tsp ground cumin
1 Tbsp ground coriander seed
2 cups (½ liter) chicken broth,
 preferably homemade
3½ oz (10 cl) soy milk
Salt

- Wash and drain the cauliflower, cut into florets. Peel and thinly slice the onions and piece of ginger. Peel the potatoes, cut them into small dice, rinse, and drain. Peel the garlic cloves, chop them in half, and remove the green germs.
- In a saucepan, heat the olive oil and sweat the onions and ginger.
- Over low heat, add the turmeric, cumin, and coriander, and stir well to mix. Then add the garlic, cauliflower florets, and potato cubes. Add the chicken broth, salt lightly, and bring to a boil.
- Cover, adjust heat, and simmer 20 to 30 minutes.
- Pour the soup into a blender and blend. Add the soy milk and blend again.
- This soup may be enjoyed hot or chilled. In the latter case, add a few ounces of water to loosen it and make it more fluid.

TIP: To keep spices from going stale, it is important to buy them often and in small quantities; store them in airtight containers, away from light.

EMOTIONS AND THE FOODS THAT TREAT THEM:
Anger: Cabbage, asparagus, legumes, celery stalk, stems of spring onions, most aromatic herbs (parsley, thyme, oregano), mint tea (especially peppermint), lemongrass.
Anxiety: Vegetables with leaves that have diuretic properties and help drain away anxious feelings: watercress, cauliflower soup, cabbage salad, berries, citrus, pumpkin seeds.
Worry: To relieve the circular thinking that fuels obsessive thoughts: fruits in bunches (grapes, sea buckthorn), small vegetables that promote diuresis, endive, melon.
Bereavement, sadness: Root vegetables such as turnips, carrots, potatoes, and also chive greens, turkey, pears, apples, sunflower seeds.

Fear: Mushrooms, melon, watermelon, citrus fruit, black sesame seeds. Most of our emotions are tied to fear or at least worry: fear of falling in love, fear of intimacy or of being alone, fear of hurting people, of saying no, of asserting oneself, fear of the future or of suffering to come.

Excitement, impatience: Stone fruits (cherry, peach, apricot).

After a strong emotion: Cooked potatoes, yams with mildly spiced chicken. Cloves and rosemary also help express emotions. In China, one confronts this kind of situation with preparations pairing steamed chicken and wood ear mushrooms.

MY CHINESE SOUP

SERVES 4

2 packets vermicelli or rice noodles,
 soaked in warm water and drained

¾ oz (20 g) wood ear mushrooms,
 soaked in warm water and drained

1 quart (1 liter) chicken broth,
 preferably homemade

1 onion, chopped

2 small leeks, cut on the bias

2 carrots, cut into small sticks

1 bay leaf

16 chicken wings

8 shrimp, peeled

2 Tbsp soy sauce

Smidgen red pepper paste, such as harissa

1 bunch cilantro, minced (about 2 Tbsp)

Salt and freshly ground black pepper

- Soak the mushrooms and vermicelli separately in warm water.
- Put the chicken broth, half the chopped onion, the chopped leeks and carrots, bay leaf, and the 16 chicken wings into a saucepan. Bring to a simmer and simmer gently about 20 minutes.
- Drain the mushrooms and vermicelli and add them to the saucepan, then add the soy sauce, red pepper paste, peeled shrimp, the remaining chopped onion, and the cilantro. Boil briefly.
- Serve in a glass bowl.

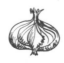

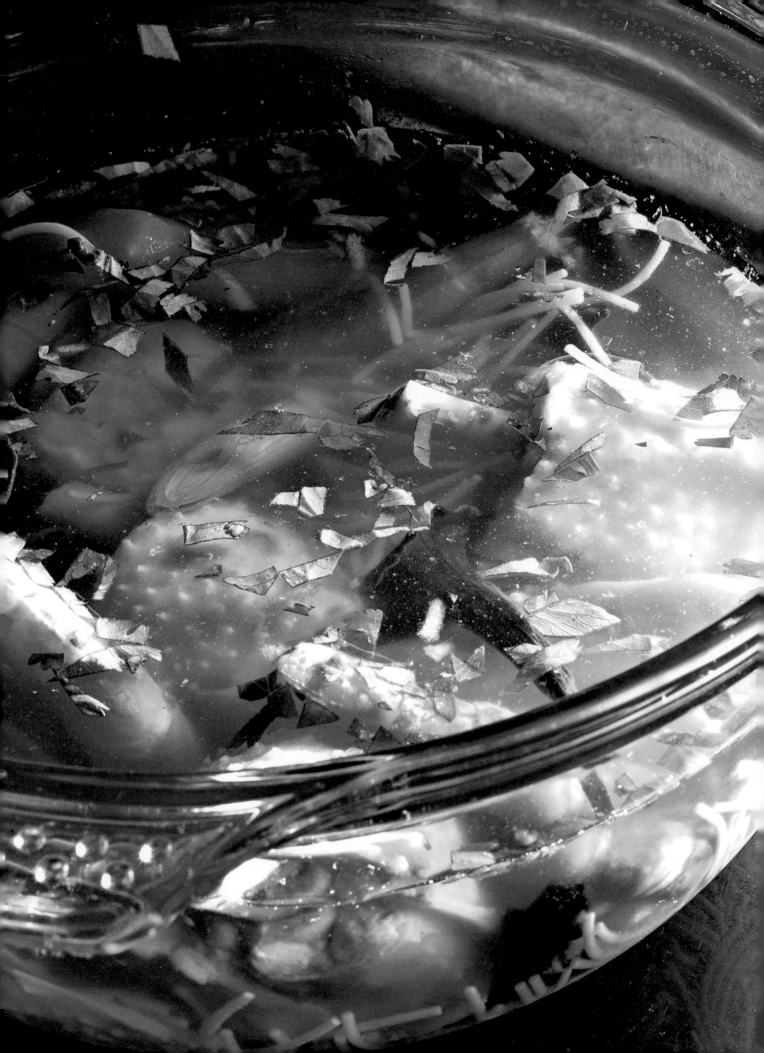

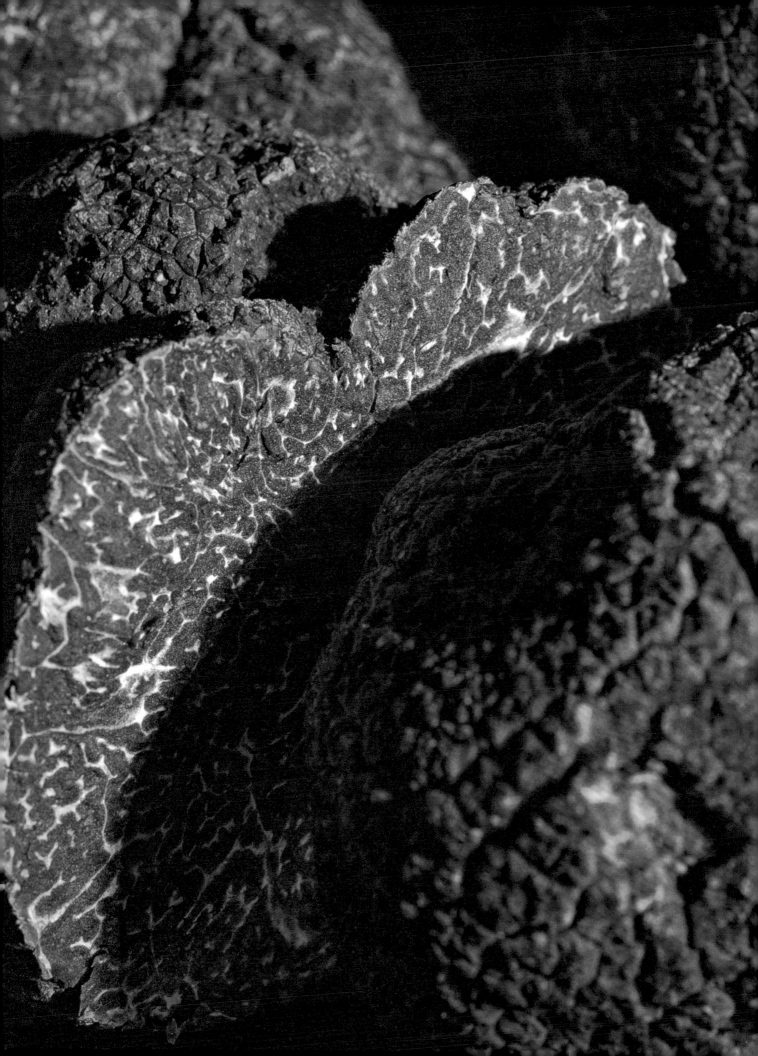

THE ORGANS AND THE FOODS THAT ARE GOOD FOR THEM:
Digestive System, Spleen, Pancreas, Stomach: Seeds, grains, meat, chicken
Liver: Legumes, mollusks
Respiratory system, lungs: Walnuts, fruit, dairy products, fish, lamb
Urinary system and kidneys: Seeds, chestnuts, mushrooms, shellfish
Cardiovascular system and heart: Quinoa, whole wheat, pistachios, adzuki beans, red beans, poppy seeds, turkey, stone fruit (cherries, peaches, apricots)

A good recipe for fighting depression: turkey, foie gras, and truffles:

MY FAVORITE TRUFFLED STUFFING FOR TURKEY

FOR 6.5-9 POUND (3-4 kg. TURKEY)

3½ oz (100 g) fatty bacon, finely diced

3½ oz (100 g) chicken livers, plus the one from the turkey, diced medium

1 black truffle, finely diced

5¼ oz (150 g) foie gras (cooked or raw), diced large

Salt and freshly ground pepper

- Very finely dice the bacon and truffle. Dice the livers a bit larger. Set aside.
- In a skillet, gently render the fatty bacon, beginning over very low heat. When it is half rendered, add the livers, season with salt and a generous amount of pepper. Cook about 2 minutes more, remove from heat, and add the diced truffle. Stir to mix well.
- In a large bowl, place diced foie gras and pour contents of skillet over it, including the rendered bacon fat. Mix well.
- Stuff and roast the turkey.

FOR FREEDOM FROM INHIBITIONS: Lamb, poultry, red lentils, adzuki beans, small vegetables, fish, strong flavors (shallots, chives), mustard greens, protein-rich grains such as quinoa. When the subject is ready to talk about his or her feelings, add some fruit.

Although it is useful for helping someone express hidden emotions, meat is, on the other hand, not advised for someone in an extreme state (overexcitement, crying spell).

LAMB CHOPS WITH POTATO CONFIT

SERVES 4

8 lamb chops, frenched (ask the butcher to trim them and to remove the backbone nerve)

2 lb (1 kg) yukon gold or other waxy salad potato, peeled and sliced into ⅛ inch (3 mm) rounds

5 medium onions, peeled and sliced into ⅛ inch (3 mm) rounds

2 bouquets garnis (in each: 3 sprigs fresh thyme, ½ bay leaf, and 6 sprigs parsley tied together)

1 clove garlic, peeled

2 cups (50 cl) chicken broth, preferably homemade

1 bunch parsley, leaves plucked

Butter and neutral-flavor oil (such as canola, grapeseed, or peanut)

Salt, freshly ground black pepper

- Remove the chops from the refrigerator. Rinse the bouquets garnis.
- Peel the onions and slice into rounds about ⅛ inch (3 mm) thick. (Use a food processor if possible, to ensure uniformity.)
- Peel the clove of garlic. Wash and dry the parsley and pluck its leaves.
- In a large pot, melt 3 Tbsp (50 g) butter over very low heat. Add the onion rounds. Cook 5 minutes over very low heat without allowing the onion to color.
- Peel the potatoes and slice into rounds ⅛ inch (3 mm) thick. Wash and drain them and put them in a large bowl. Add the onions, three-quarters of the parsley leaves, a pinch of salt, and mix well.
- Preheat the oven to 400°F (200°C/Th.8). In a skillet, heat 1 tsp of oil over medium heat and sear the chops 1-2 minutes per side until well browned; set aside on a plate.
- Rub the inside of a baking dish with the garlic clove. Butter the bottom and sides generously. Spread half the potato-onion mixture in the dish and season with pepper. Arrange the chops on top and cover them with the rest of the potatoes and onions. Sprinkle with the remaining parsley leaves.
- Pour the chicken broth and the juices from the plate of resting chops over everything in the dish and slip a bouquet garni into the potatoes on either end. Bake for 1 hour.
- From time to time during cooking, tamp everything down with a wooden spatula.
- If the potatoes seem to be browning too much or too quickly, cover the dish with aluminum foil until it comes out of the oven.

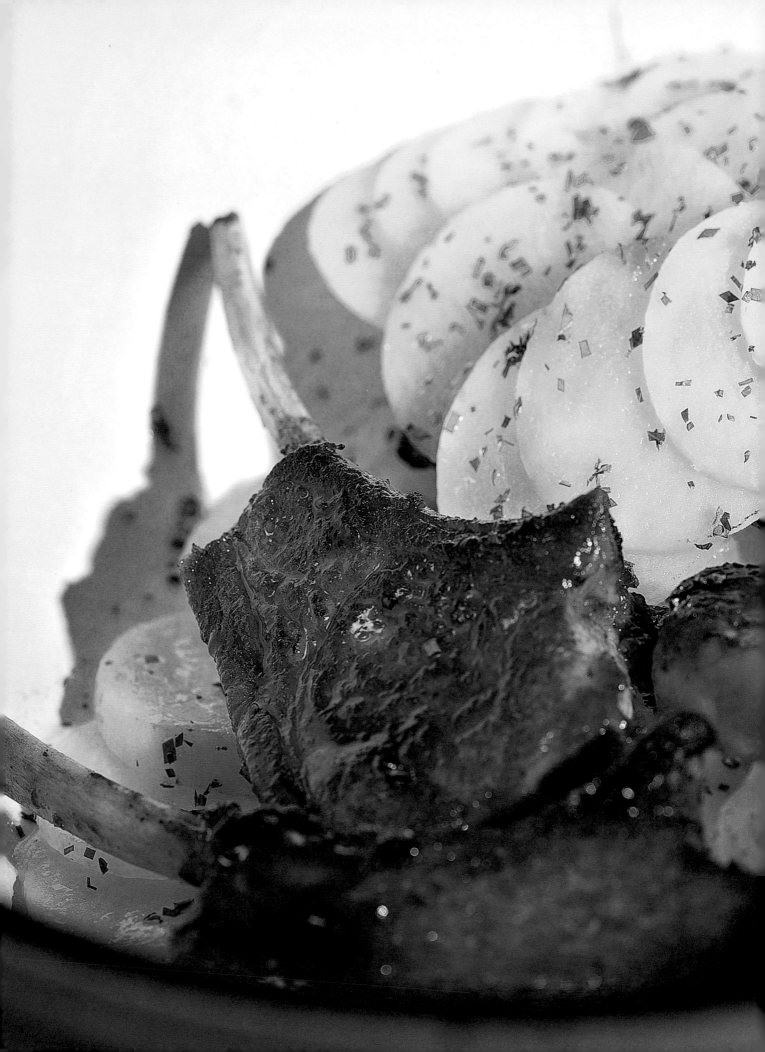

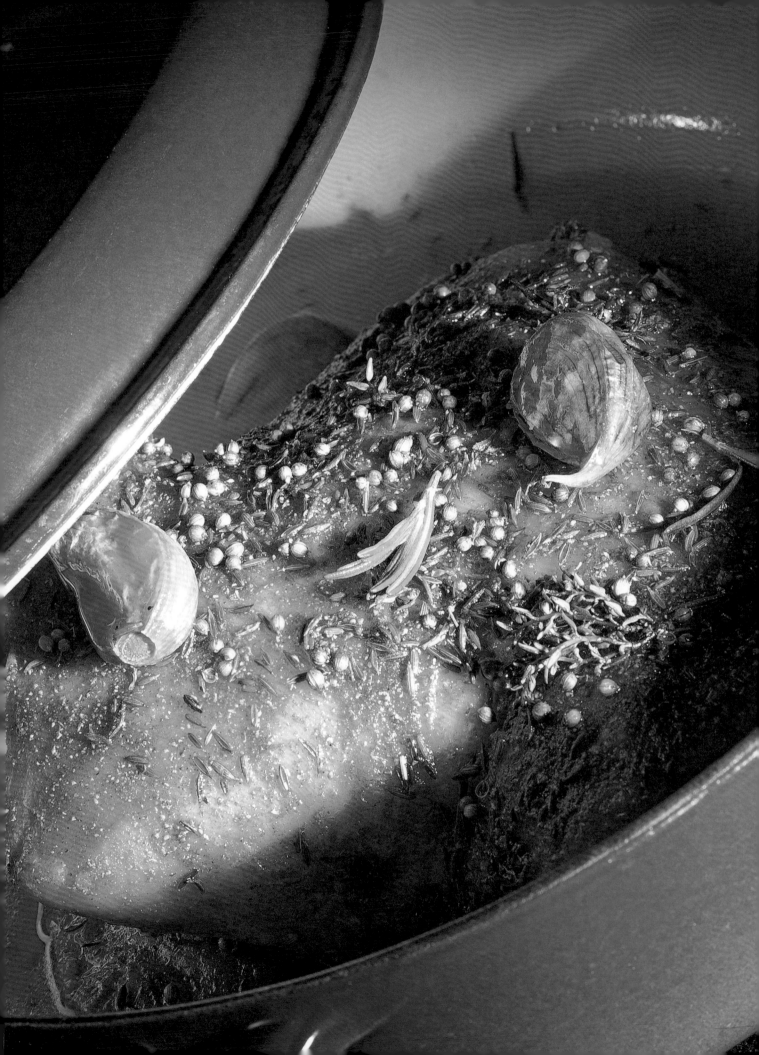

LAMB SHOULDER WITH SPICED SEMOLINA

SERVES 4

1 lamb shoulder, about 2½ lb (1.2 kg)

1 tsp or ¼ oz (5 g) coriander seed

1/4 tsp (2 g) ground coriander seed

1/2 tsp (3 g) cumin seed

1/4 tsp (2 g) ground cumin seed

1/2 tsp (3 g) Madras curry powder

1/4 tsp (2 g) black pepper

¼ cup (50 g) olive oil

A few stalks of thyme

A few rosemary leaves

4 cloves garlic

1¼ cups (30 cl) vegetable broth,
 preferably homemade

For the spiced semolina:

7 oz (200 g) medium-grain semolina
 or couscous

2 Tbsp (30 g) olive oil

¼ red bell pepper, diced small

¼ green bell pepper, diced small

1.8 oz (50 g) Zante currants or raisins,
 soaked in advance to rehydrate

1¼ cups (30 cl) hot water

Salt and freshly ground pepper

○ Rub the lamb with the spices (coriander, cumin, curry powder, pepper), sprinkle with thyme and rosemary, add garlic cloves and drizzle with half the olive oil. Wrap with plastic wrap and marinate overnight in the refrigerator.

○ Preheat the oven to 300°F (150° C/Th. 5). In a large oven-safe pot, warm the other half of the olive oil and lightly brown the lamb shoulder. Add the garlic, thyme, and rosemary from the marinade and season with salt. Pour in the vegetable broth and bring to a boil. Cover and bake in the oven for 3 hours.

○ In a large bowl, stir together semolina or couscous with 2 Tbsp (30 g) olive oil. Add the diced bell peppers and raisins. Pour in hot water and stir with a fork. Cover with plastic wrap and let rest 10 minutes. Fluff with a fork and adjust seasoning to taste.

MEATBALLS WITH TOMATO SAUCE

SERVES 4

1 lb (500 g) ground beef
1 onion, chopped
1 Tbsp flat-leaf parsley, chopped
1 Tbsp cilantro, chopped
1 heaping tsp ground cumin
1 heaping tsp paprika
1 level tsp ground ginger

1 pinch turmeric
1¼ cups (10 oz / 30 cl) tomato puree or passata
1 bay leaf
3 eggs (optional)
Salt, freshly ground pepper,
 nutmeg and cinnamon (*optional*)

- In a large bowl, mix the ground beef with the onion, herbs, and spices, and form into small meatballs.
- In a large saucepan or pot, warm the tomato puree with the bay leaf, salt, and pepper.
- In a heated nonstick skillet, brown the meatballs, then add them to the sauce and simmer 5 minutes at most (too long and they risk becoming overcooked and tough).
- The meatballs may be served this way, but another option is to crack three eggs into the sauce before it finishes cooking, and serve when the eggs are done.

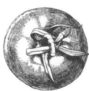

In crisis situations, one needs a soothing and calming effect. Foods that help to calm the spirit: figs, lotus seeds, pistachios, red beans, turkey, fennel.

FOODS THAT HELP REDUCE ANGER

Mollusks, oysters, clams, scallops, mussels; grains (sweet rice); vegetables (fennel, celery—also useful for high blood pressure—purple cabbage); black berries; black soy beans; mung beans; pecans, hazelnuts and coconuts; certain fish (carp, freshwater eels, sardines, herring, anchovies); egg whites (they may be added to soup); black sesame seeds, sunflower seeds and flaxseeds.

CELERY ROOT AND ENDIVE SALAD WITH WALNUTS

SERVES 4

10.6 oz (300 g) celery root, peeled and grated
1 endive, cored, cut in half lengthwise,
 then crosswise into ½-inch slices
12 bunches mâche
1 Granny Smith or other green apple, peeled, cored,
 and cut into thin sticks
Juice of one lemon
¾ oz (20 g) fresh walnuts, shelled and toasted
1 tsp coarse salt

For the dressing:
1 Tbsp strong mustard
1 Tbsp wine vinegar
3 Tbsp hazelnut oil
1 tsp chives, minced
Salt and freshly ground black pepper

○ In a large bowl, whisk together the vinegar and mustard with a pinch of salt and a pinch of pepper. Add the hazelnut oil and whisk thoroughly.

○ Bring to a boil 1 quart (1 liter) water with a teaspoon of coarse salt and the lemon juice. Peel the celery root, grate it, and boil for 30 seconds (*tip: use microwave as a timer*). Transfer to a colander, rinse under cold water, and leave in colander to drain.

○ Carefully wash the mâche and dry it. Wash and drain the endive. Using a small knife, remove the core from the bottom (this reduces the bitter taste for which many people dislike this vegetable). Cut endive in half lengthwise then crosswise in ½-inch slices. Peel and core the apple and cut into thin sticks.

○ Toss everything together in a large bowl, pour the vinaigrette over it, and toss again. Sprinkle with chives before serving.

HOT OYSTERS WITH FENNEL AND CURRY

SERVES 4

24 Pacific oysters (huîtres creuses)
2 gray shallots, peeled and finely chopped
¾ cup plus 2 Tbsp (20 cl) white wine
1 onion, peeled and finely chopped
½ fennel bulb, peeled and finely chopped
2 Tbsp salmon roe

4 Tbsp crème fraîche
1 pinch curry powder
1 Tbsp chives, minced
Generous 2 Tbsp (40 g) butter
Salt and freshly ground black pepper

- Remove the oysters from their shells over a bowl to catch the juice. Pass juice through a fine strainer lined with a paper towel and set aside.
- Peel and finely chop the shallots, and put them in a saucepan with the wine and 1 tsp of butter. Boil for about 10 minutes.
- In the meantime, brush the bottom of a large pot with 1 tsp of butter. Arrange the oysters snugly in the pot.
- Add the strained oyster liquid to the shallot–white wine mixture and bring to a boil. As soon as it bubbles, turn the heat under the oysters to medium and pour the shallot–wine sauce through a fine strainer into the oyster pot. After 30 seconds, quickly flip the oysters, wait 30 more seconds and turn off the heat.
- Quickly remove the oysters with a slotted spoon and place them on a dish. When they have cooled a bit, use small scissors to remove their beards (the viscous parts surrounding them).
- Peel the onion and the bulb of fennel and finely chop them. In a saucepan, melt 1 tsp butter: When it foams, add the onion and fennel and sauté 3 minutes over medium heat. Add the oyster cooking liquid, crème fraîche, and pinch of curry powder. Simmer 5 minutes and season with salt and pepper.
- Strain this sauce through a fine strainer into a saucepan. Cut a generous 1 Tbsp of well-chilled butter into small pieces, and add them to the saucepan, stirring with a wooden spoon.
- Add the oysters and heat a few seconds, just enough to reheat them.
- Remove the oysters with a slotted spoon. Add the chives and salmon roe to the sauce, stir to mix, and coat the oysters.

CELERY REMOULADE

SERVES 4 TO 6

14 oz (400 g) celery root, peeled, quartered,
 and grated
Juice of 1 lemon
Salt, freshly ground black pepper

For the remoulade:
1 Tbsp mayonnaise
1 tsp capers
2 medium cornichons, diced small
1 tsp flat-leaf parsley, minced
1 tsp chervil and tarragon, finely chopped

○ Stir together the remoulade ingredients in a small bowl. Wash and peel the celery root, quarter it, grate it into a large bowl, and sprinkle with lemon juice so it doesn't turn brown. Toss with the remoulade and serve chilled but not cold.

CELERY SALAD WITH PRAWNS

SERVES 4

16 large prawns, pre-cooked
8 stalks celery, peeled and cut into thin segments
2 Granny Smith apples, peeled and diced small
1 tsp celery leaves
1 tsp chives, minced

For the dressing:
4 Tbsp mayonnaise
Juice of 1 lemon
Salt and freshly ground pepper

○ Peel the celery and the apples. Cut the celery into thin segments and the apples into small dice (both, less than ¼ inch/.5 cm). Put the celery and apple into a large bowl and toss with lemon juice.

○ Remove the heads and shells of 12 of the 16 prawns. Cut each one into 6 segments, a bit larger than the apple and celery pieces. Toss with the apples and celery and 3 Tbsp mayonnaise. Add half the chives and toss well.

○ Put 1 Tbsp of mayonnaise and 1 tsp of water into a bowl. Whisk and add to the salad. Decorate the dish with the remaining 4 whole prawns, and sprinkle with celery leaves and remaining chives.

○ Serve well chilled.

PEAR AND RAISIN CLAFOUTIS

SERVES 4

3 whole eggs
¼ oz (8 g) powdered stevia sweetener
0.9 oz (25 g) flour
1⅓ cup (300 g) heavy cream

28 oz can pears in syrup
1 Tbsp superfine sugar
¼ cup raisins, rehydrated in warm water
Room temperature butter

○ Preheat the oven to 400°F (200°C/Th. 7). Cut each pear lengthwise into 8 pieces.

○ Put the raisins in a bowl, cover with warm water, allow to swell, then drain.

○ In a large bowl, break the eggs, add the stevia, and whisk two minutes until the mixture has whitened. Add the flour and cream and whisk again to mix well.

○ Brush the bottom and sides of a 9-inch round baking dish with the softened butter, then sprinkle with the sugar. Scatter the pears and raisins in the dish and pour the batter over. Bake on the middle rack for 45 minutes. Allow to cool before serving.

TIP: This recipe can also be used for cherries, apricots, apples, and so on.

APPLE, RAISIN AND WALNUT CRUTIBLE WITH VANILLA ICE CREAM

✱ FOR THE CRUST:

10 Tbsp (150 g) butter, diced

2.6 oz (75 g) sugar

¼ tsp (1.5 g) salt

1 whole egg

10.6 oz (300 g) pastry flour (or substitute equal parts all-purpose flour and cake flour)

○ Dice the butter and, in a bowl, soften it with a wooden spoon. One at a time, mixing thoroughly after each ingredient, add the sugar, salt, egg, and flour. Form the dough into a ball, wrap in plastic, and refrigerate for 2 hours.

○ After 2 hours, place the ball of dough on a floured work surface and roll it out to a thickness of ⅛ inch (2 mm). Line a 9-inch tart mold with the dough, trim the edges, and prick in several places with a fork.

TIP: Dough scraps can be baked into delicious little cookies.

✱ FOR THE CARAMELIZED APPLES:

4 apples, peeled, cored, quartered, and sliced thick

3 Tbsp (40 g) butter

1.4 oz (40 g) sugar

1 pinch cinnamon

Sprinkle of vanilla sugar

○ Peel, core, and quarter the apples, then cut the quarters into thick slices.

○ In a skillet, melt the butter and sugar and cook until caramel colored, then add the apple slices. Cook, stirring regularly, until apples are golden brown. Sprinkle with cinnamon and vanilla sugar. Allow to cool.

✳ FOR THE ALMOND CREAM:

3½ oz (100 g) ground almonds or almond flour 3½ oz (100 g) sugar

6 Tbsp plus 2 tsp (3½ oz/100 g) butter 1½ eggs

○ In a bowl, work the butter with a spatula until softened, then beat in the sugar, ground almonds, and eggs until incorporated.

✳ FOR THE CRUMBLE:

6 Tbsp plus 2 tsp (3½ oz/100 g) butter, diced Splash of rum

3½ oz (100 g) sugar 1.4 oz (40 g) walnuts, chopped

3½ oz (100 g) flour 1 pinch ground cardamom

1.8 oz (50 g) ground hazelnuts Sprinkle of confectioners' sugar

1 oz (30 g) raisins

○ In a large bowl, dice the butter and add the sugar, flour, and ground hazelnuts. Work together with a wooden spoon until the mixture looks like wet sand.

○ Preheat the oven to 350°F (180°C/Th. 6). Macerate the raisins in a little rum to rehydrate, then drain. Pour the almond cream into the dough-lined tart mold and sprinkle with the drained raisins. Arrange the caramelized apple slices on top, then sprinkle with the crumble, chopped walnuts, and cardamom, and bake for 30 minutes. When it comes out of the oven, sprinkle with powdered sugar.

Good to know: Bake any leftover crumble topping and serve it over seasonal fruit, preferably cooked.

✳ FOR THE VANILLA ICE CREAM:

6 vanilla beans 12 egg yolks

1 quart (1 liter) milk 7 oz (200 g) sugar

2 coffee beans ¾ cup plus 2 Tbsp (20 cl) crème fraîche

○ Slit the vanilla beans lengthwise and scrape out the seeds with a small knife; set aside the seeds and pods.

○ Heat the milk in a saucepan over high heat. Add the vanilla pods and coffee beans. Bring to a boil, then remove from the heat. Cover and leave to infuse for 15 minutes.

○ Put the egg yolks, sugar, and vanilla seeds in a bowl. Whisk until thick, then whisk in the milk until incorporated.

○ Pour this mixture into a saucepan and cook over medium heat, stirring with a wooden spoon, until it thickens, making sure that it does not start to bubble. Pull spoon from the mixture and run a finger down the back of the spoon: It will leave a trail when the custard is just right.

○ Remove saucepan from heat, stir in the crème fraîche, and pass through a fine strainer.

○ Allow to cool completely then churn in an ice cream maker.

FOODS TO FIGHT OBSESSIONS, BINGE EATING, AND BAD BREATH

Mild vegetables that grow in bunches; salad greens (lettuce, endive, romaine, cabbage); certain fruits (melon, watermelon, tropical fruits, kiwi, bananas, steamed plantains); legumes (all the little beans, yellow lentils, black beans); Brazil and macadamia nuts; barley; pumpkin seeds; skate; sea scallops; alfalfa, bamboo or pea sprouts; soy sprouts and sprouted grains.

BEETS AND ENDIVE WITH SMOKED DUCK BREAST

SERVES 4

2 small round beets, cooked, peeled, and diced small

2 small endives, sliced thin lengthwise

16 slices smoked duck breast

1 Granny Smith apple, cored and cut into thin sticks

1 Tbsp chives, cut in 1-inch (3 cm) lengths

For the vinaigrette:

3 Tbsp hazelnut oil

1 Tbsp tarragon vinegar

Salt and freshly ground black pepper

○ In a small bowl, whisk 1 Tbsp tarragon vinegar with a pinch of salt and a pinch of black pepper. Add 3 Tbsp hazelnut oil and whisk again. Set aside.

○ Cook and peel the beets and cut into approximately ¼ inch (.5 cm) dice. Wash the apple and core but do not peel before cutting into small sticks of the same thickness.

○ Wash the endive, separate the leaves, and slice lengthwise into strips ¼ inch (.5 cm) wide; cut these strips into sections 1-1½ inches (3-4 cm) long. Wash the chives and chop into similar lengths. Put the beets, apples, and endive into a large bowl with about three-quarters of the vinaigrette and toss well.

○ Place the salad in the middle of a deep platter, arrange the duck around the salad and drizzle with the remaining vinaigrette. Sprinkle with chives.

FOODS TO FIGHT ANXIETY AND SADNESS

Radish, turnips, lotus root, carrots, certain fruits (orange, pear—especially Asian pear—quince, persimmon, almonds, pine nuts), small white beans, millet, trout and carp, sea bass.

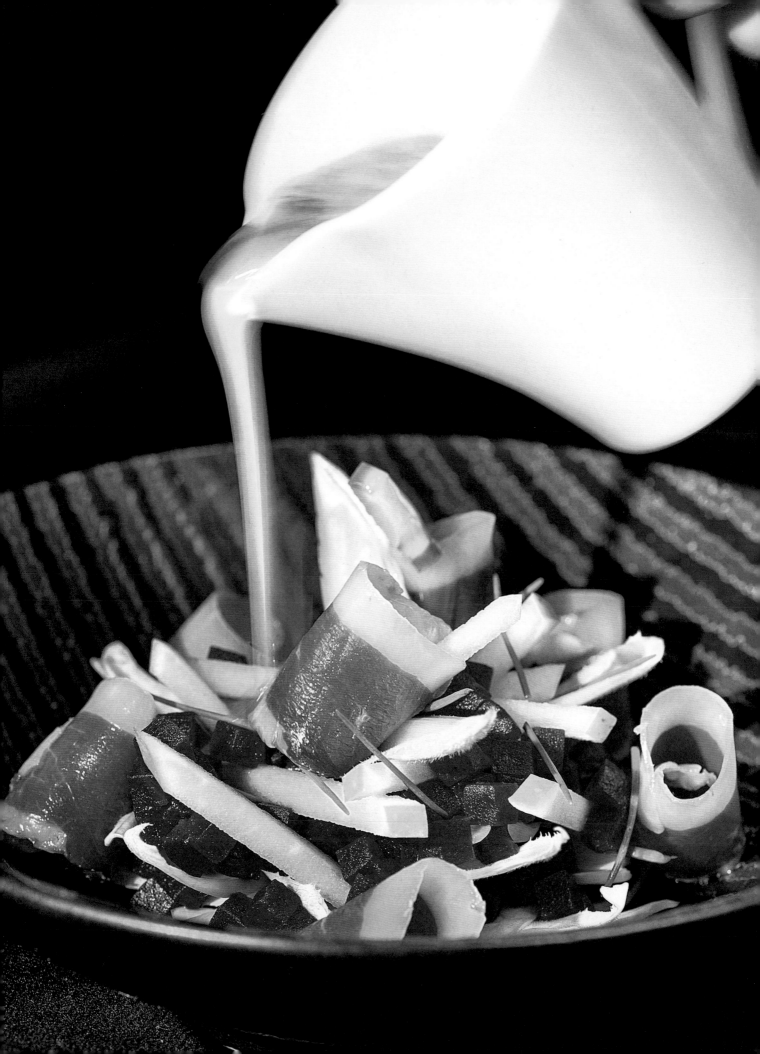

POACHED SEA BASS WITH LEEKS AND CILANTRO

SERVES 4

1 whole sea bass, gutted and scaled, 1¾ to 2 lb (0.8-1 kg)

2½ quarts (2½ liters) court-bouillon (recipe below)

4 leeks, julienned

1 bunch cilantro

1 quart (1 liter) water

1 Tbsp coarse salt

1 shot glass soy sauce

○ Fill a large saucepan (or a poissonnière, if possible) with court-bouillon and place the prepared fish in it. Bring to a boil over high heat. As soon as it bubbles, remove the pot from the flame and leave the fish to poach, covered, until broth is lukewarm.

○ Meanwhile, wash the leeks and cilantro and pluck the cilantro leaves.

○ Bring to a boil 1 quart (1 liter) water with 1 Tbsp coarse salt. Julienne the whites of the leeks and cook in the boiling water 1-2 minutes. Remove with a slotted spoon and divide into 4 equal portions, then add cilantro leaves to each portion.

○ Remove the skin and bones of the fish and divide its flesh among 4 bowls for serving. Arrange the julienned leeks and cilantro leaves on top.

○ Strain ¾ cup (20 cl) of the court-bouillon, add the soy sauce, pour it over the fish, and serve.

Court-bouillon is an aromatic broth used primarily for cooking fish and shellfish.

COURT-BOUILLON

2½ quarts (2½ liters) water

2 cups (50 cl) white vinegar

3½ oz (100 g) carrots, chopped in ½-inch pieces

3½ oz (100 g) onions, peeled and sliced into thin rounds

1 rib of celery, chopped in ½-inch pieces

1 sprig thyme

1 bay leaf

1 oz (30 g) coarse salt

¾ oz (20 g) whole peppercorns

○ In a large pot, bring to a simmer the water, carrots, celery, thyme, and bay leaf. After 5 minutes, add the onions; after another 5 minutes, add the vinegar; after another 5 minutes, add the salt and peppercorns, and simmer for another 10 minutes. Strain. Court-bouillon can be refrigerated until needed.

TROUT FILLETS WITH CARROT TAGLIATELLE AND CURRY

SERVES 4

4 trout fillets (about 5 oz [160 g] each)

14 oz (400 g) carrots, trimmed and peeled

2 cups water

1 tsp coarse salt

1 clove garlic, peeled, germ removed, and minced

3 Tbsp olive oil

1 pinch curry powder

1 tsp sherry vinegar

8 basil leaves, minced

Salt and freshly ground black pepper

○ Rinse and dry the fish and place on a dish.

○ Trim the carrots at each end, peel, and wash. With a mandoline or vegetable peeler, shave carrots into thin, wide strips, then use a knife to cut them into thinner ribbons, resembling tagliatelle.

○ In a saucepan, bring to a boil 2 cups water with 1 tsp coarse salt. Boil the carrot tagliatelle 1-2 minutes. With a slotted spoon or skimmer, remove them to a colander and rinse under cold running water 1 minute, then drain.

○ Mince the garlic clove.

○ In a large pot, heat 2 Tbsp olive oil. Add the carrots, pinch of curry powder, 1 tsp sherry vinegar, garlic, and basil. Season with salt and pepper, stir with a wooden spoon, and heat over low flame.

○ Meanwhile, season the fish fillets on both sides with salt and pepper. In a large skillet, heat 1 Tbsp olive oil over medium heat, then carefully place the trout. (Tip: Start with the end near you in the skillet and lay down the fillet away from you, to avoid being spattered.)

○ Cook 2 minutes, use a spatula to flip the fillets, and cook 30 seconds more. (*Tip: Use the microwave as a timer.*)

○ Place the carrot tagliatelle on a serving platter and arrange the fish on top.

These small turnips are perfect with duck or roast chicken.

MY CHICKEN BROTH-BRAISED BABY TURNIPS

SERVES 4

14 oz (400 g) small new turnips, all about
 the same size for even cooking, peeled
¼ oz (8 g) superfine sugar
1 pinch fine salt
3 Tbsp (40 g) butter

1¼ cups (30 cl) chicken broth,
 preferably homemade
3-6 Tbsp (5-10 cl) pan drippings
 from a roast chicken
1 Tbsp flat-leaf parsley, chopped

o Peel the turnips and put them in a large bowl with the sugar and a pinch of fine salt. Toss to coat the turnips thoroughly.

o In a large pot, melt the butter. When it is blond and foamy, add the turnips to the pot in a single layer and brown on all sides. When they are golden brown, add a third of the chicken broth and cook, covered, over low heat until the broth has been completely absorbed. Repeat a second and then a third time: When this is done, the turnips are cooked. (Turnips should never be left dry in the pot. If the broth reduces too quickly, add a bit of water when necessary.)

o Drizzle with a few spoons of chicken jus and bring to a simmer. When it begins to bubble, sprinkle with 1 Tbsp chopped flat-leaf parsley and serve immediately.

ORANGE SALAD WITH CINNAMON AND ORANGE FLOWER WATER

SERVES 4

6 oranges, peeled and supremed
1 Tbsp orange flower water
½ oz (15 g) powdered stevia sweetener
1 heaping tsp ground cinnamon

3½ oz (100 g) strawberries, washed, hulled, and drained
8 small mint leaves

○ Slice away the orange peel and all the pith. Over a large bowl to catch the juice, cut oranges into thin slices or separate the sections from the membranes. To do this, slip the blade of a small knife between the flesh of the orange section and the membrane that envelops it, and carefully remove the flesh alone, leaving the membranes behind. (The knife should be able to gently remove the intact orange section from the membrane, which will remain stuck to the neighboring section.)

○ To the orange sections and juice, add the orange flower water, cinnamon, stevia, and quartered strawberries. Cover the bowl with plastic wrap and refrigerate 1 to 2 hours.

○ Arrange the oranges and strawberries on plates in a pretty pattern. Garnish with the mint leaves and serve well chilled.

FOODS TO FIGHT FEAR

Certain vegetables (zucchini, endive), mushrooms, seaweed, certain fruits (chestnuts, melon, watermelon, tropical fruits), legumes (black beans, black-eyed peas), shellfish, mussels, certain fish (catfish, shark, grouper), sesame seeds.

MUSSELS WITH SPICY TOMATO SAUCE

SERVES 4

4.5 lb (2 kg) mussels
1 clove garlic, peeled and minced
3 Tbsp (5 cl) water
1¼ cups (30 cl) tomato puree or passata
1 Tbsp flat-leaf parsley, minced
1 Tbsp cilantro, minced

1 tsp ground cumin
1 heaping tsp paprika
2 cloves garlic, peeled and minced
¼ tsp white vinegar
1 tsp tomato paste
Freshly ground black pepper

○ Thoroughly scrub the mussels, remove the beards, and wash vigorously in several changes of water. Put mussels in a large pot with 1 clove minced garlic. Add 3 Tbsp (5 cl) water and season with black pepper. Cover and cook over high heat. When the liquid begins to bubble, count 2 minutes: As soon as the first mussels open, remove the pot from the heat. Leave covered for 2 minutes. Using a slotted spoon, remove the mussels to a colander. Strain the cooking juices in the pot through a fine strainer and set aside.

○ When the mussels have cooled a bit, remove them from the shells, reserving the flesh only. In a saucepan, heat the tomato puree. Put both aside.

○ In a small bowl, stir together the remaining ingredients, and thin the mixture with a little of the strained mussel cooking liquid. Put mixture in a saucepan on low heat and simmer 2 minutes, stirring. Add the mussels, cover with the heated tomato puree and stir to mix for 30 seconds over low heat, just enough to reheat the mussels. Season with black pepper if necessary. Serve while hot.

MUSHROOM BROTH WITH SCALLOPS AND GINGER

SERVES 4

✳ FOR THE SHIITAKE BROTH:

1 oz (30 g) dried shiitake mushrooms
(7 or 8 pieces), or dried porcini
mushrooms or cepes, cleaned and rinsed

2 cups (50 cl) chicken broth,
preferably homemade

○ Thoroughly clean the mushrooms and quickly rinse. Bring the chicken broth to a boil and pour it over the mushrooms. Cover and leave 10 minutes to infuse; strain and season. (This makes a simple, good broth, full of flavor, that one may drink on its own.)

✳ FOR THE SAUTÉED MUSHROOMS:

¾ oz (20 g) dried shiitake mushrooms,
cleaned and sliced thin

¾ oz (20 g) white button mushrooms,
cleaned and sliced thin

¾ oz (20 g) porcini mushrooms or cepes,
cleaned and sliced thin

¾ oz (20 g) oyster mushrooms,
cleaned and sliced thin

¾ oz (20 g) king trumpet mushrooms,
cleaned and sliced thin

1.8 oz (50 g) shallots,
peeled and finely chopped

3 Tbsp (40 g) butter

1 Tbsp (2 cl) olive oil

Flat-leaf parsley, chopped

Salt, freshly ground black pepper

○ Peel and finely chop the shallots. In a sauté pan, melt half the butter and add the shallots. Season with salt and pepper. Cover and cook 10 minutes over low heat.

○ Clean the mushrooms, remove the earthy bottoms, and slice thinly. Heat the remaining butter and the oil in a skillet, and cook the mushrooms until they turn a pretty pale gold. Add the sautéed shallots and chopped parsley, and season. Drain on paper towels.

✳ FOR THE SCALLOPS:

4 sea scallops, rinsed and sliced very thin

○ Briefly wash the scallops under cold running water, pat dry with paper towels. Cut each scallop into 4 or 5 very thin slices. ⟶

70

Salt, freshly ground black pepper

1 Tbsp melted butter

1 small piece of fresh ginger,

 peeled and julienned

Squeeze of fresh lime juice

○ Place the scallop slices on a plate, season with salt and pepper, and gently brush with melted butter. Peel and julienne the ginger. Lightly butter the bottom of 4 serving bowls, and arrange the buttered scallop slices in them. Top with sautéed mushrooms, then a pinch of julienned ginger.

○ Heat the shiitake broth until very hot and pour some into each bowl. This will suffice to lightly cook the thin slices of raw scallops and to reheat the mushrooms. Squeeze a few drops of lime juice into each bowl. Serve while hot.

MY FRIED ZUCCHINI

Can be served as an hors d'oeuvre with beverages, or to accompany roast meat

SERVES 6

1 lb (500 g) zucchini, sliced lengthwise,

 about ¼ inch (0.5 cm) thick

2.8 oz (80 g) flour

2 eggs

2 Tbsp peanut oil

4¼ oz (120 g) breadcrumbs

Peanut oil for deep-frying

Salt, freshly ground black pepper, fleur de sel

○ Wash and dry the zucchini, and slice about ¼ inch (0.5 cm) thick.

○ Set up a breading station: Put the flour in a deep dish; beat eggs and oil together in a second dish, season with salt and pepper; put the breadcrumbs in a third dish. One by one, dredge each zucchini slice in the flour, shake to remove excess; dip it in the egg mixture; then coat in breadcrumbs. Lay on a tray until all zucchini slices are breaded.

○ In a large, heavy pot, heat at least 2 inches of peanut oil at medium-high heat to 350°F (180°C). Fry breaded zucchini slices in small batches (about 10 per batch) for 2 to 3 minutes until golden and crunchy.

○ Remove from the frying oil with a skimmer or slotted spoon and drain on paper towels. Season with fleur de sel and serve while hot.

FOODS THAT HELP AFTER TRAUMATIC EVENTS
Certain vegetables (asparagus, red cabbage, shallots), beef liver or soup, millet, crab, lobster, prawn soup, grapes, flax and hemp seeds.

GREEN ASPARAGUS WITH PARMESAN

To accompany peppermint tea

SERVES 2

6 spears green asparagus, peeled
1 generous Tbsp olive oil
1 Tbsp butter
½ oz (15 g) shaved parmesan cheese
½ bunch chives, roughly chopped

Pan juice from a roast (optional)
4 thin slices Bayonne ham
A few arugula leaves
Salt, freshly ground black pepper

○ Peel, wash, and drain the asparagus. In a pot, heat the olive oil and butter. When it foams, place the asparagus spears side by side in the bottom of the pot, roll them in the oil and butter to coat completely, season with salt. Cook, rolling them constantly, for 5 to 6 minutes, until the asparagus is lightly firm when tested with the tip of a knife.

○ Arrange asparagus on plates, drizzle with the oil and butter from the pan, sprinkle with parmesan and chives. Drape with thin ham slices, decorate with a few arugula leaves, then drizzle with a spoonful of roasting juices if desired. Finish with freshly ground black pepper.

FOODS FOR JOIE DE VIVRE *They cure the blues, helping us rediscover morale and joie de vivre.*

BANANAS, WHICH MAKE US LAUGH

Why do monkeys always seem to be laughing? Because they eat bananas and coconuts! Bananas not only make us smile, they contain serotonin and its precursor, tryptophan, which act on the limbic system to help manage our emotional well-being and our mood. What's more, bananas contain magnesium and potassium, minerals indispensable to the proper functioning of the digestive system, the heart, and the nervous system. Finally, bananas also have a beneficial effect on the large intestine: They relax, neutralize flatulence, diminish gases and toxins, and this intestinal serenity promotes a good mood and sensations of fullness, satisfaction, and well-being.

The ancients said that we have two brains, one in the head, the other in the belly. And modern scientific studies have shown that the large intestine contains more than thirty active substances called neuro-hormones that are also found in the central nervous system. This includes tryptophan, which is secreted in large quantities in the large intestine. This is why intestinal problems and bellyaches are often accompanied by feelings of sadness or anxiety, sometimes even the need to cry like a baby. Bananas are very effective in these situations: They relieve the gut and the soul.

LEMON VERBENA

A glass of verbena tea brings peace to a troubled spirit, soothes the soul's sorrow, and chases away sadness. With a few drops of honey, it also warms the heart.

GRAPEFRUIT

A friend in need, grapefruit has the power to vanquish the exhaustion that follows stress. In fact, this state of fatigue is connected to hypoglycemia, a severe lack of sugar, stores of which the body exhausts during stressful times. Grapefruit helps to balance sugar levels and also, thanks to its vitamin C, restores energy and vigor. Grapefruit juice also regulates appetite, countering the craving for sugar and the binge eating that often accompany stress.

POPPYSEEDS

These contain natural opioids that foster a pleasant sensation of lightness, and the feeling that everything will become possible again.

TURKEY

Turkey contains an amino acid, tryptophan, which, besides playing a large role in the synthesis of proteins, is also the precursor of other substances important for nervous system function, notably serotonin, sometimes called "the good mood hormone" because its function in the central nervous system is to regulate behavior and mood, and to promote sensations of pleasure and well-being. Tryptophan is also the precursor of melatonin, the hormone secreted by the pineal gland, responsible for recognition of biological rhythms, waking, and sleep.

Grilled turkey kebab, recipe on next page.

GRILLED TURKEY KEBAB

To serve with a salad of tomatoes and cilantro

SERVES 2

10-14 oz (300-400 g) turkey breast,
 cut into bit-size cubes
1 onion, minced
Sweet paprika, salt, freshly ground black pepper

1 generous pinch ground saffron
2 Tbsp flat-leaf parsley, finely chopped`
1 tsp white vinegar
2 Tbsp olive oil

○ Put the turkey breast pieces in a large bowl with all other ingredients and combine to coat thoroughly. Allow to marinate in the refrigerator for 1 hour, then place turkey cubes onto skewers. Preheat grill and cook turkey skewers about 8 minutes.

TURKEY BREAST WITH ENDIVES EN COCOTTE

SERVES 4

1½ to 1¾ lb (700-800 g) turkey breast
8 medium endives, cored but left whole
1 quart (1 liter) water
1 tsp coarse salt

1 Tbsp olive oil
1 Tbsp flat-leaf parsley, chopped
Salt and freshly ground black pepper

○ In a saucepan, bring to a boil 1 quart (1 liter) water with 1 tsp coarse salt. Rinse the endives and drain. Using a small knife, remove the core from the bottom of each endive to reduce its bitter taste. Cook the whole endives in the saucepan at a brisk boil for 20 minutes, then drain.
○ On a dish, season the turkey breast with salt and pepper. In a large pot, heat 1 Tbsp olive oil over medium heat, then brown the turkey 1 minute per side, turning it with tongs or a spatula (be sure not to pierce with a fork, to keep juices in the meat). Tuck the whole endives all around the turkey and sprinkle everything with chopped parsley. Cover and cook over low heat 5 minutes per side, turning the endives and turkey without piercing them. Turn off heat and leave 5 minutes more. Serve from the pot.

CHAPTER 3
THE VIRTUOSITY OF THE MAGICIAN

Does one ask a pianist if he likes to sit down at his keyboard? A painter if he comes to life before his canvas? A dancer if his turns and leaps are a daily necessity?

For a great chef, it's somewhat the same: Nobody imagines—he himself especially—that he could be anything other than passionate about his trade. But just as the pianist must play his scales and the dancer must work at the barre, the chef's passion begins at the market, the vegetable garden, or at the fishmonger's. Any chef will tell you:

Choosing the ingredients is already the beginning of pleasure, the springboard of the imagination that will lead to the creation and execution of a new recipe.

Certainly, in the great starred houses, the chef no longer goes out every night to make his purchases: Very proud of having been selected, vegetable farmers, butchers, and fishmongers bring their best products to his door. But woe unto him who betrays the tacit trust that is the only contract governing this relationship. Even if he doesn't browse the market stalls as often as he used to, the chef still begins his day by inspecting the deliveries, for it is from them that he will draw his inspiration, give shape to his desires, and build the performance.

The painter truly exercises his passion only in the solitude of the atelier and, even in concert, the soloist almost always finds himself alone with his music—a fundamental difference from the cook, whose whole art is based on sharing: Teamwork is a necessity. This idea of sharing goes hand in hand with a natural generosity: colors, aromas, tastes, *la gourmandise* is never satisfied by chiaroscuro or half-measures. On the other hand, this demands a fine sense balance, not piling the plate with flavors whose pairings they have not yet truly mastered.

Like Matisse, who in three or four strokes created a white bird in the blue sky, a great chef needs only three or four flavors to create a masterpiece. This sense of balance is the sure signature of true talent.

Joël Robuchon's tricks

SECRETS OF ACIDITY

This is often ignored: The presence of an acidic element prevents potatoes from cooking all the way through. We therefore avoid adding white wine to our gratins.

Although not very noticeable when tasted raw, tomatoes possess a natural acidity that is often emphasized when cooked. Therefore, before heat is introduced, add a bit of sugar, which recalibrates the sensation in the mouth.

HOMEMADE CHERRY PITTER

This cherry pitter, as effective as many of those sold in specialty stores, has two advantages: First, it is free, as it is made of found objects; second, it is disposable, keeping the drawers uncluttered by an accessory that is used only occasionally. Take a cork and stick a paperclip or hairpin into it; this will allow you to seek out the stone in the heart of the fruit.

STRAWBERRIES

Whatever preparation is planned, avoid doing too much to strawberries. To wash them, proceed by small quantities: Plunge them into cool water, gently agitate, drain, then dry with paper towels. Only now should they be hulled: If it is done in advance, water will penetrate the cut flesh, waterlogging the fruit and diluting its flavors. Ways of preparing them are innumerable, but it is key to know that a brief marinade in a dash of wine vinegar intensifies their flavor—and that they are just as good cooked as raw.

PEELING CHESTNUTS

Chestnuts are very hard to peel, and the tips often given—a stint in the oven or boiling water—are not really satisfactory. I use a small knife to score them all the way around the circumference, then I lower them into frying oil at 350°F (180°C) for about a minute. Then they open up on their own. When they come out of the fryer, carefully drain them on paper towel, then it is very easy to peel them.

PEELING BELL PEPPERS

At first glance, peeling a bell pepper seems like a difficult task, but it's actually quite simple. Put the washed peppers into a 465°F (240°C) oven for 20 minutes, turning them regularly. Remove them from the oven, place them in a large bowl and cover it with plastic wrap. This is the whole trick: After 20 minutes, the steam trapped in the covered bowl will have loosened the skins, which then may be easily removed with a small sharp knife.

PEELING TOMATOES

There are many methods for peeling tomatoes, and even special knives dedicated to this task. But the simplest ways are generally the most effective. This one, for instance: Jab the fruit

with a fork and hold it over a gas flame until its skin splits, then it will be very easy to remove.

HOME-GROWN CHIVES

Among the herbs, chives are one of the most elegant, and without doubt the most flavorful. To have some at hand all year long, even if you don't have a garden, plant 5 or 6 shallot bulbs in a flower pot. Not too deep, the bulbs need only a fine layer of soil to just cover them. Put the pot near a window in the brightest corner of your kitchen. Within a few days you will see small green shoots, which in ten days or so will be 6 to 8 inches (15 to 20 cm) tall. To harvest them, simply use a pair of scissors. The shallots will keep producing for about a month. In my kitchen, I always have three pots, and each week I replant one of them.

FAVA BEANS

It is not enough to shell the fava beans, the unpleasant-tasting skin covering each individual bean must also be removed. Simply boil them for 30 seconds in salted water (1 Tbsp of coarse salt per quart/liter), then with a slotted spoon remove them to an ice-water bath. Drain them when they have cooled, and they will have become very easy to peel. At this time, also remove the small, swollen sprout at one end, as it only contributes bitterness. Fava beans can be prepared many ways, but in my opinion, the herb called savory is their indispensable companion.

LENTILS

Long scorned during the postwar years, like most dried beans, these legumes have returned to favor today thanks to their richness in proteins and in slow sugars, making them a favorite of vegetarians and diabetics.

Before cooking them, follow a few simple rules to help avoid a number of inconveniences. For instance, contrary to popular belief, soaking them the night before to swell them, tenderize them and—they say—render them more digestible, has the exact opposite effect, for they are quick to ferment and to sprout, which is bad for the intestines and the palate.

Simply rinse them thoroughly (they can be dusty), drain very carefully, cover with cold water, and bring to a boil in order to blanch them a few seconds, and immediately drain them again. Then they are ready to be transferred to the saucepan.

They will swell a good deal, so use three parts water (¼ oz/7 g salt per quart/liter water, no more) per one part lentils. Begin cooking over gentle heat and leave the pot uncovered, so you can skim off the scum: about 10 minutes are generally enough for the water to become clear again. Then add aromatics according to your own taste, cover, and cook at a low simmer 40 to 50 minutes depending on the variety.

GREEN CABBAGE

Green cabbage requires some preparation before it is even cooked. First remove the large leaves, cut off the stem, and quarter the cabbage, then cut out the core, taking care not to separate the leaves. Rinse the cabbage thoroughly in a sinkful of water with a bit of vinegar, spreading the leaves to get rid of all particles of dirt and to hunt down any little beasties that might be hiding. Plunge the cabbage quarters into well salted boiling water and cook at a rapid boil for 10 to 15 minutes, remove to an ice-water bath to stop the cooking and to fix the color, then quickly drain. Press the quarters firmly between two flat plates to extract all the water. The cabbage can now be cooked as desired.

CLEANING MUSHROOMS

Chanterelles:

With a small knife, cut off the earthy end of the mushrooms. In a large bowl, rinse the chanterelles thoroughly in a good deal of water, without allowing them to soak, for they will absorb too much water and lose much of their flavor. Bring 2-3 quarts (2-3 liters water) to a boil in a large pot, salt it, and add the chanterelles for 2-3 seconds, just to blanch them. This will shock their surface, trapping and fixing their color. Remove and drain thoroughly.

White button mushrooms:

These have the maddening trait of being quite dirty. To clean them correctly, one must quickly dunk them into cold water by hand so that the dirt ends up at the bottom of the basin. Repeat the operation two or three times before carefully drying the mushrooms with a kitchen cloth or paper towel.

Porcini:

Begin by separating the stems from the caps. With a brush, gently brush the caps, especially the lower surface gills. If they are still dirty, try to clean them with a damp rag, or quickly pass them under running water without allowing them to soak (when swollen with water, they will taste bland). With a small knife, generously cut away the earthy ends of the stems and peel them to remove the surface skin. If you must hold the porcini for a few hours, keep them upside down in the vegetable drawer of the refrigerator, so that any little creatures hiding in them will come out on their own.

BROTHS

Before pouring a broth or fumet through a strainer to filter it, leave it to rest at the edge of the cooktop for 10 minutes or so, giving any suspended impurities time to fall naturally to the bottom of the pot. Line the strainer with a moistened muslin cloth, then ladle the liquid through the strainer, being careful not to disturb the stock pot too much. In this way, one achieves perfectly effective filtration.

MY 147°F (64°C) SOFT-BOILED EGG

This method calls for 35 minutes of cooking, and requires a cooking thermometer and unflagging attention to maintain a precise and constant temperature, but it produces without fail an egg whose white is just set while the yolk remains runny. This is invaluable for a great number of preparations. (And it is delicious: I enjoy one often with a bowl of rice and a drizzle of soy sauce.) In a saucepan, heat some water to a precise temperature of 147°F (64°C), and maintain this throughout the operation. Slip in the egg and let it cook 35 minutes. When it comes out of the saucepan, crack the shell: It looks like a hard-boiled egg, but it eats like a soft-boiled egg.

Secrets of the skillet

CRISP AND GOLDEN OR SOFT AND TENDER?

Onions and potatoes can be cooked crisp and golden, or soft and tender, the choice is yours. To obtain the former, heat the cooking fat first, then add the ingredients. But remember: Salt prevents browning; therefore, salt just before serving. For a soft and tender finish, heat the ingredients and the cooking fat together at the same time, and salt right at the beginning.

TO SAUTÉ POTATOES

In cooking as in other things, certain gestures are instinctive, but not always adequate. This is true with many ingredients, and notably sautéed potatoes. Often people imagine that they must stir constantly for even cooking, but the truth is exactly opposite. They must be left alone and given time to brown slowly on one side before they are turned to brown on the other. This way, they will cook evenly without sticking to the skillet.

Secrets of cooking

GREEN BEANS

Wash and trim the green beans. In a saucepan, bring 2 quarts (2 liters) water to a boil, add 1.4 oz (40 g) coarse salt, and boil the green beans for 5 minutes. With a slotted spoon, remove the beans right away and drop them into an ice-water bath, then drain on paper towels.

POTATOES

Always choose potatoes of the same size for uniform cooking, and always wash them thoroughly before cooking. Put them in a saucepan and cover with cold, salted water (¾ oz or 20 g per quart/liter), add 4 cloves garlic (unpeeled), a bunch of thyme, bring to a boil and simmer for about 30 minutes.

SMALL VEGETABLES WITH BIG FLAVOR

For soups, cutting the vegetables into very small pieces, such as a julienne, has several advantages. First, they cook much more evenly if they are all the same size. Further, they release more flavor because there is greater surface area in contact with the broth. Finally, a single spoon holds several vegetables and some broth, offering a variety of flavors in one bite.

Seasonings

PEPPER: GROUND OR CRUSHED?

To season a dish, peppercorns, white or black, have no equal. But to give up the best of themselves, they must be ground to a fine powder at the very last minute. Therefore one should avoid like the plague all those pre-ground peppers, which for weeks have been making a gift of all their flavor to the supermarket displays. In my kitchen I have a small electric mill devoted to this purpose, and I clean it very thoroughly after every use to eliminate any risk of interfering flavors or odors. In certain cases, however, crushing the peppercorns into rough fragments rather than grinding them into a powder them yields a more assertive taste. This can be done with a mallet on a wooden plank, in a mortar and pestle, or with the bottom of a small cast-iron skillet.

SAFFRON: RED GOLD

It has often been given the nickname "red gold" because it is the most expensive spice in the world, produced by a certain crocus. Each flower has only three stamens, tiny filaments about 1 inch (3 cm) long, red in the best varieties. When dried, they play a part in numerous recipes, for the piquant flavor and slight bitterness, or to lend color to a dish, paellas for example. Only a very small amount is used, so as not to overpower other seasonings.

As with truffles, there exist very many different varieties of saffron, whose gustatory interest is as variable as the price. I buy it only in filaments, to be sure of the quality. When it is sold as a powder, as is most frequently the case, the producer may be tempted to mix in something else to increase profit. If one wants color only, this is not a big deal, but the flavor is sure to suffer.

Finally, saffron is an herb of surprising power. This is another reason it is used parsimoniously. Special care must also be taken to avoid letting it infuse a liquid or sauce for too long, as it can bring a little too much bitterness.

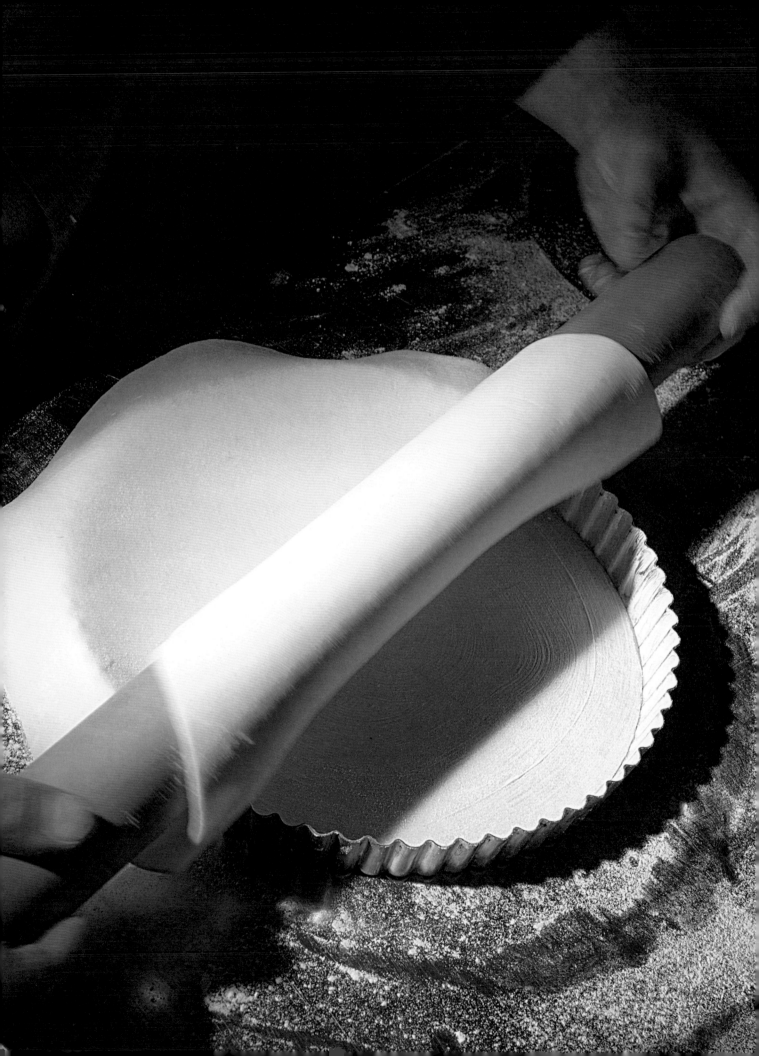

PASTRY AND PASTA DOUGH

RICH DOUGH FOR TART OR QUICHE CRUST

10 Tbsp (150 g) softened butter
8 oz (250 g) flour
4 egg yolks

3 Tbsp (5 cl) lukewarm water
1 pinch salt

● Cut the butter into pieces, put it in a bowl with the pinch of salt and mix it with a wooden spoon or spatula until very soft. Add the egg yolks and work them in until completely assimilated. Add the lukewarm water a little at a time, while working the mixture. Add more water only when the previous addition has been completely incorporated. Add half the flour and blend it in thoroughly. Finally add the remaining flour, gently mixing just until assimilated. Do not work it too hard with your hands to smooth it out: This dough must remain rather soft.
● Pull the dough into a ball, wrap in plastic wrap, and refrigerate for at least 30 minutes, but not more than 24 hours (if it sits longer, it will darken).

Cannelloni, ravioli, and lasagna can also be made with the following pasta dough.

PASTA DOUGH FOR TAGLIATELLE

SERVES 4

1½ lb (700 g) flour
2 whole eggs

1½ cups (350 g) egg yolks
¼ cup plus 2 Tbsp (10 cl) white wine

● Put all ingredients in the bowl of a stand mixer and combine using the dough hook. Refrigerate at least 1 hour.
● Roll out the dough with a rolling pin until you have a rectangle about $\frac{1}{32}$ inch (1 mm) thick, then loosely roll up this strip. Use a knife to cut the rolled-up strip into rounds; these will be the tagliatelles.
● This dough should not be salted, especially if it will be used right away, as the salt will show up as unsightly little white dots. Instead, salt the pasta cooking water well.

ZUCCHINI AND MINT SPAGHETTI

SERVES 4

8 oz (250 g) spaghetti

2 large zucchini

1 half clove garlic, peeled and chopped

5 fresh mint leaves

2 Tbsp olive oil

1 Tbsp pine nuts

2 tsp (plus a pinch for garnish) parmesan cheese

Salt and freshly ground black pepper

- With a zester (or with a paring knife and then a knife) make "spaghetti" from the zucchini, using only the dark green skin.
- In a saucepan, bring to a boil 1½ quarts (1.5 liters) water and salt it well. Blanch the zucchini strips for 1 minute, then remove to an ice-water bath to stop the cooking and fix the color: They should remain crunchy.
- Put the mint leaves, pine nuts, garlic, parmesan, salt, and pepper in a food processor and chop, then drizzle in olive oil until the sauce has the consistency of pesto. Set aside.
- In a saucepan, bring to a boil 2 quarts (2 liters) water and 1 Tbsp coarse salt. Turn heat down to a small bubble, add the spaghetti pasta, and cook about 6 minutes for an al dente texture (test the cooking by tasting a piece), stirring three or four times with a large fork. Pour into a colander and drain very well.
- Wipe any traces of cooking water from the pot and add back the pasta, the zucchini "spaghetti," and the mint pesto. Mix well.
- To serve, give each dish a drizzle of olive oil and a sprinkle of parmesan if desired.

SAERRY VINEGAR PASTA

SERVES 2

2.8 oz (80 g) tagliatelle (or 8 oz [240 g] fresh pasta)

2 large white button mushrooms, cleaned, dried, and diced small

½ onion, peeled and chopped

½ green bell pepper, peeled, seeded, and diced small

½ red bell pepper, peeled, seeded, and diced small

2 generous Tbsp olive oil

2 scant Tbsp sherry vinegar

1 Tbsp butter

Salt and freshly ground black pepper

- Peel and chop the onion. Peel the peppers and remove their seeds, then cut them into small dice. Wipe the mushrooms clean under running water, dry, and cut into small dice.
- Heat the olive oil in a skillet, add the chopped onion, season with salt, stir and cook 1 minute, without allowing it to color. Add the diced green and red bell peppers and continue cooking for 3 minutes, stirring from time to time. Add the diced mushrooms, season with salt and pepper, and cook for 2 minutes, stirring. Turn off the heat, pour in the sherry vinegar, and stir.
- In a large pot, cook the pasta al dente. Drain thoroughly and place in a serving dish. Pour the vegetable mixture on top, add 1 Tbsp butter, toss, and adjust seasoning if necessary.

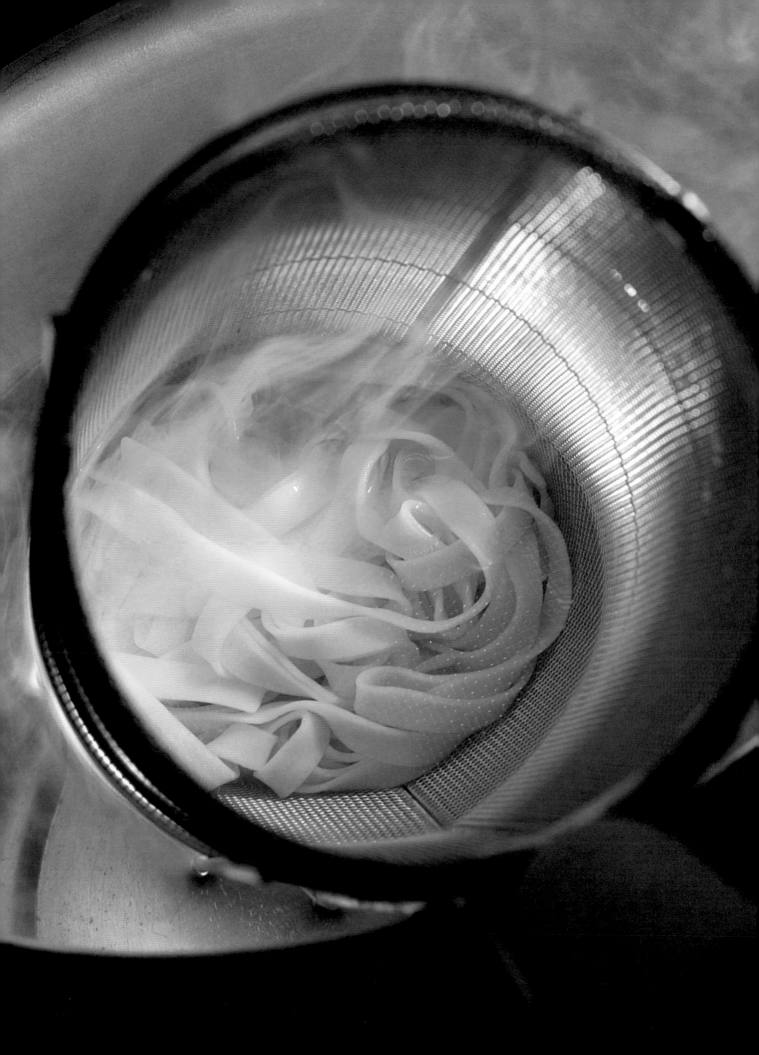

DESSERTS

SACRED CHOCOLATE!

It is often ignored that chocolate has an exceptional propensity for picking up flavors. This can be delicious, when it's a matter of vanilla or praline, but it's an entirely different matter when a cake is waiting in the refrigerator next to seafood or a ripe camembert. So chocolate creams, sweets, and pastries that will be refrigerated for more than an hour should be kept in their original packaging or transferred to perfectly airtight containers.

CHOCOLATE FONDANT TART

SERVES 4

8 oz (250 g) sweet tart dough (half batch of the Rich Dough for Tart Crust recipe on page 94)

1½ cups (35 cl) heavy cream

²/₃ cup (15 cl) milk

10 oz (300 g) chocolate

2 eggs

- Preheat the oven to 400°F (200°C). Line a 9-inch round tart pan with the dough, letting it overlap the edges by about ¹/₃ inch (1 cm), and blind bake for 10 minutes.
- Chop the chocolate into small pieces.
- Pour the cream and milk into a saucepan and slowly bring to a boil over medium heat. When it begins to bubble, remove from the flame right away and add the chocolate. Whisk well until the mixture is perfectly smooth.
- Beat the whole eggs with a fork, then add them to the chocolate mixture, still off heat, whisking energetically to prevent the eggs from cooking: This is the recipe's trickiest step.
- When the tart shell has taken on a pretty golden color, remove it from the oven. With a knife, cleanly trim any crust that sticks above the rim of the pan to leave it the edges very even.
- Lower the oven temperature to 320°F (160°C). Pour the chocolate mixture into the tart shell and bake 18 minutes. The filling should be set, but still wobbly in the center.

BROWNIE CAKE

SERVES 4

8 oz (250 g) dark chocolate (70%), chopped

10 Tbsp (150 g) butter

3 eggs, beaten

1.8 oz (50 g) powdered stevia sweetener

1.8 oz (50 g) flour

1.4 oz (40 g) walnuts or chocolate chips or disks, baker's preference

¼ tsp (2 g) salt

- Preheat the oven to 350°F (180°C).
- Cut the butter and chocolate into small pieces.
- If you don't have a double boiler, make a bain marie by placing a heatproof bowl on top of a large saucepan or pot half filled with boiling water. Put the chocolate pieces into the bowl or the top pan of the double boiler. Over low heat, melt the chocolate, stirring with a spoon. When it is almost completely melted, add the diced butter, reserving 1 Tbsp, and stir vigorously to melt it and mix it into the chocolate, still over low heat.
- Remove the bowl or top pan from the water bath and add the beaten eggs, stevia, and salt. Incorporate the flour in two additions. To finish, stir in the walnuts, chocolate disks, or chocolate chips.
- Butter a 9-inch square baking pan with reserved 1 Tbsp softened butter. Pour the batter into the tin and bake 15 minutes. Turn off the oven but leave the tin inside for 5 minutes.
- Remove tin from oven and allow to cool somewhat, then unmold the cake. When it is completely cool, slice the cake into individual servings.

For this recipe, I prefer canned pears, which, contrary to what you might think, have more flavor. This coulis may be served with many desserts and sweets.

PEAR COULIS

SERVES 4

13 oz (380 g) pears in syrup, drained and diced

²/₃ cup (15 cl) reserved pear syrup

½ star anise

½ tsp (3 g) black peppercorns

½ cinnamon stick

½ vanilla bean

Zest of 1 lemon

Zest of 1 orange

1 Tbsp pear eau de vie

○ Drain the pears from the can, reserving the syrup. Dice the pears.

○ Pour ²/₃ cup (15 cl) of the reserved pear syrup into a saucepan, bring to a boil, and remove from heat. Add the star anise, peppercorns, lemon and orange zests, cinnamon stick, and the seeds from the ½ vanilla bean. Cover and let infuse, off heat, about 15 minutes. Strain syrup into a blender, add diced pears and 1 Tbsp pear eau de vie, and blend to puree and emulsify.

FRUIT COULIS

MAKES 8 OZ

8 oz (250 g) ripe fruit of choice, washed, stemmed, pitted, cut in small pieces (strawberries, raspberries, apricots, cherries, black or red currants, etc.)

3½ to 7 Tbsp (50 to 100 g) powdered confectioner's sugar

Juice of 1 lemon

○ Wash the fruit and remove any stems or pits. If the fruit is larger than bite size, cut into small pieces.

○ Put the fruit in a blender and blend into a smooth puree. Taste; if desired, add up to 1 Tbsp each confectioner's sugar and fresh lemon juice, according to the acidity of the fruit and desired sweetness level. (For example, apricots and red currants may need more sugar and less lemon juice than raspberries.) Blend a moment and taste again, repeating until the puree has the desired balance of sweet and tart.

○ Place a strainer over a small bowl, pour the mixture into the strainer, and use a spatula to press the puree through the mesh to strain out any skin, pulp, or seeds.

○ The coulis may be stored in the refrigerator for a few days.

CREAMS

CHANTILLY

◦ Pour 1 cup well chilled heavy cream into a large bowl and add the seeds of half a vanilla bean. Set this bowl in a larger container of cold water and ice cubes.

◦ Begin by whisking gently with sweeping gestures in order to incorporate as much air as possible into the cream, which should, little by little, make bubbles; then, as the cream grows in volume, whisk faster. Stop whisking when it is firm and lightly coats the whisk: If you go past this stage, it may turn into butter and lose its homogeneity. Sprinkle in ¼ cup confectioners' sugar and quickly mix it in.

◦ If you can turn the bowl upside down and the chantilly does not fall out, that is the sign that it is ready. It must be eaten soon, for it keeps only a few hours in the refrigerator.

TIP: This cream must be eaten within a few hours of preparation because it quickly becomes toxic.

ALMOND CREAM FOR CREPES

This is the simplest recipe I know for almond cream. The secret of its success? Exactly equal proportions of almonds, sugar, and butter.

SERVES 6 TO 8
2 oz (60 g) ground almonds or almond flour
2 oz (60 g) softened butter
2 oz (60 g) confectioners' sugar
1 Tbsp heavy cream
1 whole egg
1 Tbsp rum

◦ In a large bowl, whisk together the ground almonds and butter. Then incorporate the whole egg, heavy cream, and confectioners' sugar. Whisk until the mixture turns white, add the rum, and whisk a bit more to mix it in well. This goes well with the Minute Crepes recipe on page 110.

MY VANILLA CRÈME ANGLAISE

SERVES 4

2 cups (½ liter) whole milk
2 vanilla beans
6 egg yolks
4.4 oz (125 g) superfine sugar
1 coffee bean

○ Slit the 2 vanilla beans lengthwise and scrape out the seeds. Put the seeds into a saucepan with the milk, emptied vanilla pods, and 1 coffee bean (which heightens the taste of vanilla). Bring to a boil, stirring well. Remove saucepan from heat, cover and let infuse 5-10 minutes.
○ Put the egg yolks into a bowl with 4.4 oz (125 g) superfine sugar; mix well with an electric hand mixer. Little by little the mixture should become smooth, grow paler, and double in volume.
○ Pour in the infused milk and mix together quickly so that the whole mixture becomes liquid. Heat over low flame, stirring well with a spatula until mixture thickens. Be careful it does not boil.
○ Check for proper consistency: Dip the spatula into the cream, remove it, and run a finger across it: The cream on the spatula should hold the finger's track. If the cream spreads or runs, it has not cooked long enough.
○ Strain the cream into a bowl nestled in ice; leave until cold. Serve and eat within a few hours.

ICE CREAM

MY LIGHT AND FAST RASPBERRY ICE CREAM

SERVES 4

10.6 oz (300 g) frozen raspberries

5.3 oz (150 g) fat-free cream cheese, well chilled

7 oz (200 g) unsweetened 2% evaporated milk, well chilled

2 tsp (10 g) aspartame sweetener

○ It's really as simple as can be: Put the frozen fruit in a blender, add the cream cheese, evaporated milk, and sweetener. Blend for about 1 minute, and it's ready. It is delicious and truly light—only 67 calories for 3½ oz (100 g).

MY QUICK STRAWBERRY SORBET
SERVES 4

5.3 oz (150 g) frozen strawberries, quartered

2.8 oz (80 g) fat-free cream cheese, well chilled

1.4 oz (40 g) unsweetened 2% evaporated milk, well chilled

2 tsp (10 g) aspartame sweetener

○ Put all ingredients in the well-chilled bowl of a food processor or blender; blend about 1 minute. Serve right away. Good and truly light!

LIME SOUFFLÉ CREPES

SERVES 4

4 crepes (use recipe below)
1 lime
2 (60 g) petit suisse cheeses
 or ½ cup similar cream cheese, 30% fat

3 eggs, separated
2 oz (60 g) superfine sugar
Fine salt
Fruit coulis, any flavor (or use recipe on page 103)

- Preheat the oven to 350ºF (180ºC). In a large bowl, zest the lime, add the petits suisses, the 3 egg yolks (reserving the whites), and half the sugar; whisk to combine.
- In another bowl, put the egg whites and a pinch of fine salt. Whisk gently, gradually adding the rest of the superfine sugar. Do not allow the whites to get too firm. Gently fold the egg white mixture into the first bowl.
- Divide this mixture among the four crepes, placed on a greased baking sheet. Fold the crepes in half, smoothing the exterior of each crepe with a spatula.
- Bake for 12 minutes at about 350ºF (180ºC). Serve immediately with your chosen coulis.

This recipe easily makes crepe batter that can be used right away, without having to let it rest.

"MINUTE" CREPES

MAKES ABOUT 24 CREPES

8 Tbsp (120 g) butter
8 oz (250 g) flour
3 whole eggs plus 2 yolks
3½ oz (100 g) superfine sugar

2 cups (½ liter) milk
Flavoring of choice: orange flower water,
 rum, lemon zest
Salt

- In a saucepan over medium heat, melt the butter until it is nut brown.
- In a blender, combine the flour, whole eggs, yolks, sugar, milk, and a pinch of salt. Blend for about 10 seconds. Add the browned butter and blend 10 seconds more. Add the chosen flavoring (orange flower water, rum, lemon zest) and the batter is ready to be used.
- To keep crepes soft until it is time to serve them, cover with a towel or an overturned plate. To keep crepes warm, place them on a flat dish resting atop a saucepan two-thirds full of simmering water.

CHAPTER 4
FOOD AND CLIMATE

Food can help regulate the body's temperature and also organize its resistance to climatic conditions. Clearly one cannot eat the same things when it is cold as during a heat wave.

WARMING FOODS: Well suited to cold spells, they belong to winter and are good for kidney function; the urinary, genital, and skeletal systems; the joints; and the ears.

COOLING FOODS: Useful during times of high heat, they are in season in summer, promoting function of the cardiovascular system, blood vessels, heart, and language.

FOODS USEFUL WHEN IT IS VERY WINDY, as is often the case in springtime, to promote the functioning of the hepatic system (liver and gall blader), muscles, and eyes.

FOODS USEFUL WHEN IT IS HUMID to promote the functioning of the digestive system, spleen, pancreas, and stomach as well as the mucus membranes of the mouth and the flesh.

FOODS USEFUL WHEN IT IS DRY to promote the functioning of the respiratory system, sinuses, bronchial tubes, and lungs as well as the skin and the nose.

Cold spells

WARMING FOODS
Aromatic herbs and spices: cayenne and Sichuan peppers, oregano, cinnamon, rosemary, garlic
Honeydew melon
Pine nuts, almonds
Red meat, especially roasts
Vegetables with strong flavors: parsley, chives, green onions, frisée, dandelion, arugula, astragalus root
Berries, raw or steamed

WARMING BEVERAGES
Add spices to fruit juices to augment their warming action
Combine fruit and vegetable juices with spices
Alcohol, made from fruits or grain; fruit eaux de vie
Coffee: It not only warms but also neutralizes the effects of humidity
Broths and soups
Maple syrup

PAN-FRIED VEAL CHOPS WITH CHANTERELLES

SERVES 2

1 lb (500 g) bone-in veal chop,
 fat trimmed and reserved
2 Tbsp grapeseed oil
2 generous Tbsp (40 g) butter
1 shallot, peeled and finely chopped
1 stem thyme

2 cloves garlic
5.3 oz (150 g) chanterelle mushrooms
1 Tbsp flat-leaf parsley, minced
Salt, freshly ground black pepper

- Season the veal chop with salt, pepper, and thyme.
- Heat generous 1 Tbsp (20 g) butter and a drizzle of grapeseed oil in a very large skillet over medium heat. When this is hot, add the fat trimmings, 2 garlic cloves, and veal chop.
- Lower the heat and cook 5-7 minutes on the first side. Turn and cook 5-7 minutes on the other side, frequently spooning the cooking juices over it. The veal should be tender and a little rare.
- Place an overturned bread plate atop a large plate. When the veal chop is cooked, season it and place it on the upside-down plate. Leave to rest 10 minutes.
- Return the skillet to high heat and add ¼ cup plus 2 Tbsp (10 cl) cold water. Deglaze, stirring with a spatula to scrape up any residue. Reduce the liquid by two-thirds. Taste and adjust seasoning. Put this jus through a fine strainer. Set aside, keeping it warm.
- While the chop rests and the jus stays warm, prepare the chanterelles: Clean them with paper towels and then, if they are large, cut them in half (or even into quarters) lengthwise.
- My trick for getting every last bit of flavor out of sautéed chanterelles: Lower them for 2-3 seconds into a large pot of boiling salted water, then drain. This "sears" the outside of the chanterelles, so they keep their color and fragrance.
- In a skillet, warm a drizzle of olive oil and generous 1 Tbsp (20 g) butter. Add the drained chanterelles, lower the heat, add the finely chopped shallot and stir 30 seconds more. Remove from heat and add 1 Tbsp minced flat-leaf parsley.
- On the serving dish, arrange the chanterelles around the veal chop, with the jus on the side.

DICED BEEF FILLETS WITH WASABI SPINACH AND HARLEQUIN PEPPERS

SERVES 2

2 beef fillets, 7 oz (200 g) each

¼ each red, green, and yellow bell peppers,
 cut into matchsticks

20 shimeji (Japanese brown beech) mushroom caps

2 handfuls spinach sprouts

3 generous Tbsp (50 g) butter

1 grate fresh wasabi

Salt, freshly ground black pepper,
 crushed peppercorns

Jus from a beef roast

○ Rub beef fillets with a few crushed peppercorns and season with salt. Heat a drizzle of olive oil and scant 1 Tbsp butter in a skillet and brown the beef on both sides. When cooked as desired, set the fillets aside on a rack.

○ In the skillet, heat generous 1 Tbsp butter until it turns a pretty pale gold. Add the bell peppers and shimeji mushrooms and cook about 1 minute. Season with salt and pepper and set aside.

○ In the skillet, heat generous 1 Tbsp butter until it turns a pretty pale gold. Add spinach and cook about 1 minute. Off heat, add 1 grate of wasabi and a pinch of salt.

○ In a serving dish, arrange the spinach and beef fillet, cut into bite-size cubes. Top with the sautéed vegetables. Drizzle lightly with beef jus and top with a grind of black pepper.

FOODS FOR FIGHTING THE COLD OR OVERCOMING PAIN
(for instance, menstrual cramps): strong-flavored vegetables (garlic, onions, green onions), aromatic herbs (parsley, chives), certain fruits (plums, cherries).

Heat and heat waves

COOLING FOODS

Vegetables: zucchini, squash, gourds, pumpkin, cucumber, steamed or pureed green vegetables (their chlorophyll has a cooling effect); for instance, asparagus soup, the greens of spring onions, bamboo shoots

Legumes: green peas, mung beans

Aromatic herbs: parsley, thyme, oregano

Melons

Sprouts: barley, wheat, raw vegetable sprouts

Duck and rabbit meat

Eggs (especially egg whites, stirred into a soup)

Mushrooms

Seafood: mollusks (especially clams)

Fruits: oranges and peaches, fresh juice, dates

Yams (very cooling when added to a soup)

Flax seeds

Nuts: walnuts, hazelnuts, nut oils

Peppermint, lemongrass

GRATED CARROTS WITH LEMON AND GARLIC

SERVES 6 TO 8

1 lb (500 g) peeled carrots

2 large cloves garlic (or more if desired), chopped

3 Tbsp flat leaf parsley, chopped

For the dressing:

2 Tbsp fresh lemon juice

Fine sea salt

1½ Tbsp extra-virgin olive oil

1½ Tbsp peanut oil

○ To make the dressing, pour the lemon juice in a small bowl, season with salt and whisk vigorously; slowly add the two oils, whisking all the while until the mixture is homogenous. Adjust seasoning and set aside.

○ Finely grate the carrots (by hand or with a food processor), toss with the garlic in a salad bowl. Pour the dressing and toss to mix. Sprinkle with parsley and serve at room temperature.

TIP: You can make this salad several hours in advance, or even the night before; just cover and refrigerate.

CUCUMBER-AVOCADO MAKI

SERVES 2

1 cucumber, peeled and cut into 3 segments
3 sticks imitation crab
1 medium carrot, peeled and julienned

½ avocado, cut lengthwise and
 sliced into three sections
⅓ cup plus 2 Tbsp (10 cl) soy sauce

- ○ Peel the cucumber and carrot. Cut the cucumber into three segments the same length as the imitation crab sticks.
- ○ Using a sharp knife, slice around the cucumber segments lengthwise, cutting them into thin wide bands about 6 inches (16 cm) long.
- ○ Julienne the carrot and remaining centers (omitting the seeds) of the cucumber. Cut the avocado half lengthwise, and slice one half into three sections.
- ○ On a piece of plastic wrap, lay a band of cucumber and place on top an imitation crab stick, a third of the carrot and cucumber julienne, and a piece of avocado. Roll up tightly, like a sushi or maki roll. Remove the plastic wrap and cut each piece into three pieces. Repeat for the two other cucumber segments.
- ○ Serve with soy sauce for dipping.

SEA BASS WITH AROMATICS

SERVES 2

2 sea bass fillets, 5 oz (150 g) each

¼ zucchini, diced small

¼ bulb fennel, diced small

¼ green bell pepper, diced small

¼ red bell pepper, diced small

½ celery stalk, diced small

8 black olives, diced small

½ clove garlic, green germ removed

1 tsp small capers

1 piri piri pepper (Tabasco pepper), chopped

3-4 threads saffron

¾ cup plus 2 Tbsp (20 cl) olive oil

1 tomato, diced small

1 stem thyme

½ bunch basil

1 carrot, finely chopped

3 white onions, finely chopped

1 tsp black peppercorns

1 bouquet garni

Juice of 1 lemon

Fleur de sel, freshly ground black pepper, a few basil leaves

o Blanch the diced zucchini, fennel, bell pepper, and celery briefly in a pot of boiling salted water, then plunge into an ice bath. Drain, then put into a large bowl, add ¾ cup plus 2 Tbsp (20 cl) olive oil, diced tomato, black olives, and capers, 2 finely chopped small white onions, the chopped piri piri pepper, a few threads of saffron, the thyme, and a small bunch of basil. Refrigerate until ready to serve.

o In a saucepan, pour 2 quarts (2 liters) water, salt well, and add 1 finely chopped onion, 1 finely chopped carrot, 1 tsp black peppercorns, and the bouquet garni. Boil 5 minutes. Remove from heat, add lemon juice and the two sea bass fillets. Cover and set aside for 10 minutes to poach.

o Remove the sea bass fillets to paper towels to drain, then place on plates. Cover the fish entirely with the chilled marinated vegetables, sprinkle with fleur de sel, a grind of black pepper, and a few basil leaves.

TOMATO SALAD WITH CELERY LEAVES AND ARGAN OIL

4 large tomatoes, well washed, peeled, seeded, and diced small

4 Tbsp small celery leaves, finely chopped

3 generous Tbsp argan oil

1 large clove garlic, minced

2 Tbsp lemon juice

Fine salt, fleur de sel, freshly ground pepper

o Wash and peel the tomatoes, remove the seeds, and cut into small dice.

o In a salad bowl, combine the oil, lemon juice, salt, and pepper using a small whisk. Add the diced tomato, garlic, and finely chopped celery leaves; toss to combine. Refrigerate for at least 30 minutes to allow the flavors to bloom and come together.

o Just before serving, add a small pinch of fleur de sel and freshly ground black pepper.

For breakfast:

POACHED EGGS

SERVES 4

4 eggs
¾ cup (20 cl) white vinegar

○ In a saucepan, bring 2 quarts (2 liters) water to a boil; add ¾ cup (20 cl) white vinegar. It is important NOT to salt the water. Bring up to a simmer again.

○ Break the eggs individually into ramekins. When the water is beginning to simmer, gently slip the eggs into the water one by one, then reduce the heat: The water should be shivering but not boiling.

○ Check the cooking by touching the white with the tip of a spoon: The white should coagulate while the yolk inside stays creamy. This should take 2 to 2½ minutes for the average egg.

○ When the eggs are perfectly cooked, remove the saucepan from the heat and immediately, with a slotted spoon, gently slip the eggs into ice water to stop cooking.

○ Before serving, carefully trim the edges of the eggs to regularize their shape.

COOLING BEVERAGES
Peppermint tea, lemongrass tea
Cherry juice and apricot juice, always diluted with water
Contrary to what one might think, hot soup can also have a cooling effect: In all Asian countries with hot climates, soup is a part of every meal.

Examples of foods good to eat when it is hot: zucchini and squash blossoms, cauliflower, lavender, pumpkin. Fruits: berries, cranberries, oranges, lemon, papaya.

INDIAN SUMMER AND TRANSITIONAL SEASONS
BENEFICIAL FOODS AND BEVERAGES
 Offal
 Zucchini
 Pearl barley
 Winter melon
 Watermelon
 Rind of melons and tropical fruits:
 for example, an infusion of made of boiled peels
 Beverages made of fruits harvested in late summer:
 the juice of melons, watermelons, apricots, kiwis, or starfruit.

PAN-FRIED SKATE WING WITH CABBAGE

SERVES 4

4 skate wings, 7 oz (200 g) each
1 lb (500 g) mussels
1 small pale green cabbage
2 tomatoes, peeled, seeded, and diced
12 hazelnuts, peeled and chopped
3 generous Tbsp (50 g) butter
4 Tbsp olive oil
1 shallot, peeled and finely chopped

Curry powder
Salt, freshly ground black pepper

For the vinaigrette:
1 Tbsp peanut oil
1 Tbsp hazelnut oil
1 Tbsp balsamic vinegar
1 tsp capers, chopped

o Thoroughly clean the skate wings in water, washing away all viscous matter, then dry them with paper towels.

o Carefully scrub the mussels, remove and discard the beards, and rinse them thoroughly in several changes of water.

o Cut off the cabbage stem, remove the large outer leaves, quarter the cabbage, and remove the core.

o In a saucepan, bring to a boil 1 quart (1 liter) water with 1 tsp of coarse salt. In a large bowl, prepare an ice bath of very cold water and ice cubes. When the water in the saucepan boils, blanch the cabbage in it for 5 minutes, then use a skimmer or slotted spoon to remove it to the ice bath for 2-3 minutes. Drain and pluck the leaves.

o Put the mussels in a large pot, season with pepper while stirring, then cover. Cook over high heat for 4 minutes, shaking the pot a few times. Remove the mussels with a skimmer or slotted spoon, remove them from their shells and put them aside, reserving the cooking liquid in the pot.

o In a bowl, pour the balsamic vinegar, add 2 pinches fine salt, and whisk. Take a spoonful of the mussel cooking liquid, pour it through a fine strainer, and add it to the vinegar along with the oils and capers. Whisk everything together.

o Season the skate on both sides with salt, pepper, and a pinch of curry powder. In a large skillet, heat 4 Tbsp olive oil over high heat, place the skate wings in the skillet side by side and cook 2 minutes per side, turning them with a spatula. Remove skillet from heat and cover with aluminum foil.

o In a large pot, melt generous 3 Tbsp butter and add the cabbage, mussels, hazelnuts, tomato, and shallot. Cook over medium-high heat, stirring. Taste and adjust seasoning if necessary.

o Transfer to a serving dish, place the skate wings on top, coat with vinaigrette, and serve.

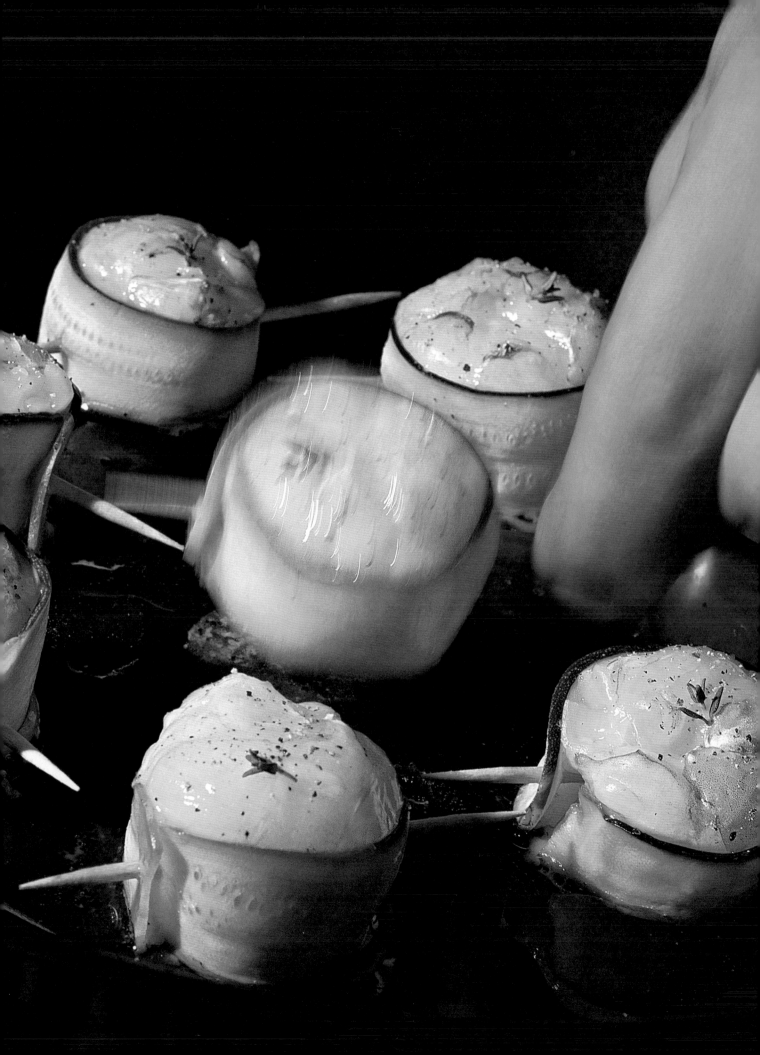

LANGOUSTINE FRICASSEE WITH ZUCCHINI AND MUSHROOMS

SERVES 4

16 fresh langoustine tails, peeled

2 small firm zucchini

2 shallots, peeled and minced

2 cloves garlic, peeled, degermed, and minced

8 oz (250 g) chanterelle mushrooms

8 oz (250 g) oyster mushrooms

2 Tbsp flat-leaf parsley, minced

2 Tbsp peanut oil

1 Tbsp butter

2 Tbsp goose fat

A few stems of fresh thyme

Salt, freshly ground black pepper

- With a vegetable peeler, shave 8 thin strips from the skin of each zucchini.
- Rinse the langoustine tails and dry them with paper towels. Wrap a zucchini strip around each tail in a spiral and hold it in place with an olive pick or wooden toothpick. Set aside.
- Peel the shallots and chop very finely, preferably with a food processor. Peel the garlic, remove its green germ, and chop very finely .
- In a large sauté pan, heat 2 Tbsp peanut oil until very hot, add the chanterelles, and season with 2 pinches of salt and one of pepper; add the shallots. Cook about 5 minutes, drain the chanterelles and keep warm on a plate.
- In the same sauté pan, melt 1 Tbsp butter over high heat. When it is very hot, add the oyster mushrooms, season with 2 pinches of salt and 1 of pepper and cook 3 minutes. Remove from the heat and stir in the chanterelles, minced garlic, and minced parsley. Season with salt and pepper if necessary, drain, and set aside.
- Still in the same sauté pan, melt the goose fat over high heat. When it is very hot, brown the zucchini-wrapped langoustine tails 2 minutes per side. Season with 1 tsp salt and 2 pinches of pepper. Sprinkle with a pinch of thyme.
- Remove the wooden picks and place the langoustines in the center of a serving dish. Arrange the mushrooms all around them and serve immediately.

Spring: The windy time

TO COMBAT A DISTENDED ABDOMEN, COMMON IN THIS SEASON:
parsnip, daikon radish; grapes, pears, cherries, and plums livened up with spices; wine; coffee; grains; berries; honey and molasses

IN THE CASE OF VERY STRONG WINDS:
steamed duck; lotus or banana leaves; parsnips, celery, romaine, radishes; asparagus soup

NOTE This is a two-part recipe: First make the confit, and possibly preserve it for storage.
When it is time to eat it, pan-fry or grill it.

GOOSE OR DUCK CONFIT

SERVES 2

For goose:
2 goose legs, about 1⅓ lb (600 g) each
3⅓ lb (1.5 kg) goose fat
¼ cup plus 2 Tbsp (10 cl) water

For duck:
2 duck legs
2 lb (1 kg) duck fat
¼ cup plus 2 Tbsp (10 cl) water

For the marinade:
1 clove garlic, peeled and degermed
1 oz (30 g) coarse salt
1 stem fresh thyme
2 whole cloves
1 tsp crushed pepper

For preservation:
Lard
1 large stoneware crock
 with a cover and a glazed interior

○ The night before: Rinse the thyme, place the legs on a large deep dish covered with plastic wrap plus enough extra wrap to thoroughly wrap the legs in it. Rub the meat with the garlic, then with the coarse salt. Sprinkle with fresh thyme leaves, rubbing the sprig between your hands, and discard the stem. Add the cloves and the pepper, thoroughly wrap in plastic wrap, and refrigerate for 24 hours.

○ The next day: In a saucepan, melt the fat over lowest possible heat, and add ¼ cup plus 2 Tbsp (10 cl) water. Remove the meat from the refrigerator, discard the cloves and pepper and use a brush to carefully remove all traces of salt and thyme.

○ When the fat is just barely beginning to simmer, carefully lower the legs into it. Still over lowest possible heat—the cooking must be done very slowly and very gently—simmer 1 hour 40 minutes for duck, or 2 hours 30 minutes for goose. You can check doneness by probing with a large needle: The juice that comes out should be perfectly liquid. With a skimmer or slotted spoon, remove the legs to a rack.

○ To preserve the confit: While the legs rest on the rack, clarify the fat: Use a small ladle to remove any scum from the surface. Put a fine strainer over a large bowl, then carefully ladle all the fat from the upper half of the pot through the strainer and into the bowl, making sure not to take any browned bits from lower down.

○ With the same ladle, put about ¾ inch (2 cm) of the strained fat into the stoneware crock, then refrigerate the crock until the fat solidifies, about 10 to 15 minutes.

○ When this is done, remove the crock, place the legs on the bed of fat without allowing them to touch each other or the sides (they must be completely submerged in fat all around) and cover the legs with three-quarters of the strained fat remaining in the large bowl. Cover

and refrigerate. Transfer the remaining strained fat to another tightly closed container and refrigerate. After a day or two, gently reheat this remaining strained fat until it is liquid, then pour it into the stoneware crock to fill any remaining pockets of air.

⦿ Refrigerate again for at least an hour to allow the fat to solidify. When it has solidified, heat enough lard to make a ¹/₃ to ¾ inch (1-2 cm) layer at the top of the crock: Denser than goose or duck fat, lard insures that the confit will be better preserved.

⦿ Refrigerate again. When the lard has solidified, press a sheet of waxed paper onto its surface and cover the crock with its lid. Thus prepared, the legs should keep 5 to 6 months in the refrigerator.

⦿ To pan-fry or grill the confited legs: Preheat the oven 10 minutes in advance to 400°F (200°C/Th.7). In a skillet or on a grill, brown the legs (5 minutes for duck, 8 minutes for goose) on all sides over rather high heat. Arrange them in a baking dish so that they do not touch one another, then bake on the second highest rack for 5 minutes (duck) or 7 minutes (goose).

SEA SCALLOPS WITH ARGAN-OIL VEGETABLES

SERVES 4

For the scallops:
12 sea scallops
1 Tbsp chives, minced
1 tsp ginger, peeled and minced
1 tsp olive oil
1 tsp argan oil
Salt, freshly ground black pepper

For the vegetables and sauce:
7 oz (200 g) carrots, peeled and diced
7 oz (200 g) asparagus, diced
7 oz (200 g) snow peas, diced
Fine salt and coarse salt
¼ cup plus 2 Tbsp (10 cl) chicken broth,
 preferably homemade

2 Tbsp crème fraîche
3 Tbsp plus 1 tsp (50 g) butter
2 tsp argan oil

For the semolina or couscous:
1 oz (30 g) medium-grain semolina or couscous
3 Tbsp (5 cl) chicken broth, preferably homemade
1 Tbsp argan oil
Salt, freshly ground black pepper

For the spinach:
7 oz (200 g) baby spinach, washed and stemmed
1 Tbsp plus 1 tsp (20 g) butter
Salt
A few mustard leaves, thoroughly washed

◦ Quickly rinse the scallops under running water, then dry thoroughly with paper towels. Season with salt and pepper. Mince the chives, peel the ginger, and mince as small as possible. Heat the olive oil in a skillet and add the scallops. Cook 1 minute, then sprinkle with chives, minced ginger, and argan oil. Set aside.

◦ Peel the carrots and chop into small, uniform dice, then dice the asparagus and snow peas in similar size. Bring water seasoned with coarse salt to a boil, then blanch each vegetable in turn for 30 seconds. Set aside.

◦ In a large pot, heat ¼ cup plus 2 Tbsp (10 cl) chicken broth with the crème fraîche, add the vegetables, butter, and 1 Tbsp argan oil; season with salt. Cook 5 minutes.

◦ In winter, this sauce is perfect for turnips, celery root, salsify, and Brussels sprouts.

◦ In a small bowl, add the semolina or couscous and 1 Tbsp argan oil; season with salt and pepper. Heat 3 Tbsp (5 cl) chicken broth, pour over the semolina, and stir thoroughly with a fork. Cover with plastic wrap and leave for 5 minutes to absorb. →

- Heat 1 Tbsp plus 1 tsp (20 g) butter in a sauté pan and wilt the spinach for 2 minutes, without allowing it to begin to brown, and season with salt.
- On each plate, arrange 3 pan-fried scallops on a bed of spinach, surrounded with vegetables and drizzled with a bit of sauce. Sprinkle with semolina and garnish with mustard leaves.
- The mixture of chives and ginger also makes an excellent accompaniment for fish and poultry.
- This flavored semolina may also be served with a simple side of vegetables.

STIMULATING DISHES

The best sources of energy: mushrooms, seafood, marine mollusks, fish eggs (caviar), chicken. Absinthe is also very invigorating. The recipe below, which brings together very stimulating ingredients, is rather easy to make and just what the doctor ordered.

CHICKEN WITH PRESERVED LEMON

SERVES 4

4 boneless, skinless chicken breasts, cut into strips
1 Tbsp olive oil
1 onion, peeled and very thinly sliced
1 clove garlic, peeled and minced
1 Tbsp crushed coriander seed

1 small pinch powdered saffron
1 small preserved lemon,
 skin cut into small dice
3 to 4 saffron threads
Salt and freshly ground black pepper

- Slice the chicken breasts into strips, place them on a dish and season with salt and pepper. Heat a wok over low heat, add 1 Tbsp olive oil, onion, and garlic and cook 2 minutes, stirring with a wooden spatula; do not allow the onion and garlic to begin to brown.
- Add the chicken and sauté 2 minutes over medium-high heat, stirring regularly, then lower the heat. Add the saffron, preserved lemon, and coriander and sauté 2-3 minutes more, depending on thickness of chicken strips. Serve very hot.

EGGPLANT CAVIAR

SERVES 4

3 good-sized eggplants, scored
1 clove garlic, peeled and sliced
3 cups plus 2 Tbsp (75 cl) olive oil
Salt and freshly ground black pepper
Optional: cumin, curry powder

o Preheat oven to 425°F (220°C/Th.7). Peel the clove of garlic and slice it into almond-shaped slivers, and then slip these into incisions scored in the eggplants' skin. Wrap each eggplant in aluminum foil and bake for 40 minutes. After they are cooked, remove their caps and skins, chop the flesh, and place in a food processor.

o Add olive oil, and cumin and curry if you wish, and season with salt and pepper; blend until it is the consistency of hummus. Serve warm or cold.

MUSHROOM VELOUTÉ

SERVES 4

1½ lb (700 g) white button mushrooms, cleaned, dried, and sliced
1.4 oz (40 g) dried mushrooms (porcini, trumpet, chanterelles), rinsed
3 cups (70 cl) chicken broth, preferably homemade
1 clove garlic, peeled and finely chopped
1 tsp coriander seeds
1 Tbsp chervil leaves, 4 leaves reserved for garnish
¾ cup (20 cl) light cream
Salt, freshly ground black pepper

o Cut the dirty stem ends from the mushrooms and rinse them several times in cold water, without allowing them to soak. Dry and slice thinly. Rinse the dried mushrooms to remove any residual dirt.

o In a large pot, pour the chicken broth, mushrooms, garlic, and coriander seeds. Bring to a simmer, cover, and cook 15 minutes over low heat.

o Transfer the broth and mushrooms to a food processor or blender, add the chervil (setting aside four leaves for garnish) and blend.

o Strain blended mixture through a chinois into a saucepan, pressing the solids against the side of the strainer with a ladle. Add the cream, adjust seasoning if needed, and bring to a boil, and remove from heat.

o Garnish with reserved chervil leaves and enjoy right away.

ESCARGOTS WITH SPICED BROTH

SERVES 4

6 dozen escargots,
 thoroughly washed and drained

1 rounded tsp green anise seed

2 generous Tbsp caraway seed

3 level Tbsp thyme

1 rounded tsp sweet paprika

1 scant tsp green tea

1 bit of licorice root

1 branch wormwood

1 good-sized bunch mint

Peel of 1 orange

3 hot red chiles

2 pieces gum arabic, crushed
 (obtain from a pharmacy or herbalist)

Salt

○ Wash the escargots in several changes of water until the water remains clear, drain. Place them in a large pot with enough water to amply cover them, and boil 4 to 5 minutes. Drain, rinse well with cold water, and drain again.

○ Bring 4 quarts (4 liters) water to a boil and season with 1 oz (30 g) coarse salt. Make a bouquet garni with the spices and aromatics in a piece of cheesecloth tied with kitchen string, and place sachet in the salted water. Boil 2-3 minutes, then add the escargots all at once, making sure they are completely covered by water. Turn heat down to a simmer.

○ Cook the escargots in the barely simmering broth for 1 to 1½ hours, depending on their size, stirring 2 or 3 times. When the bodies detach from the shells and the flesh is no longer rubbery, remove from the heat and adjust seasoning if necessary.

○ Serve in the broth, hot or warm according to your preference.

DISHES THAT DELIGHT

Certain foods are particularly beneficial for the heart: grains (quinoa, whole wheat), nuts (pistachios, almonds), stone fruits (cherries, apricots, peaches), legumes like Japanese red beans (adzuki), sunflower and poppy seeds (which contain—in small quantities—opium, invigorating the heart and the nervous system). Turkey is also recommended because it contains the amino acid tryptophan, which promotes joie de vivre and emotional balance.

CHESTNUT CONFIT WITH PEARL ONIONS AND WALNUTS

SERVES 4

2 lb (1 kg) chestnuts

12 pearl onions, minced

12 gray shallots, minced

1 small fennel bulb, thinly sliced

3 cups (70 cl) chicken broth,
 preferably homemade

7 oz (200 g) black trumpet mushrooms,
 washed and dried

2 Tbsp plus 2 tsp (40 g) butter

8 fresh walnuts, shelled

Fine salt and freshly ground black pepper

o In a large sauté pan, heat 1 Tbsp plus 1 tsp (20 g) butter, add the minced pearl onions, minced shallots, and sliced fennel, and cook until everything begins to take on some color.

o Add the chestnuts and chicken broth, and cover with a round of parchment paper. Cook over low heat for about 40 minutes, stirring as little as possible in order to keep the chestnuts intact.

o While the chestnuts are cooking, put the remaining butter and the mushrooms in a saucepan, season with salt, cover, and cook until the mushrooms have given up their liquid, then drain, pressing them against the side of a strainer.

o Transfer the mushrooms to the sauté pan, add the, walnuts and cook everything together for about 5 minutes. Serve the chestnut confit tossed with meat or poultry jus.

CLAFOUTIS MY WAY

SERVES 4

5 whole eggs

4½ oz (130 g) superfine sugar

2 oz (60 g) flour

1 Tbsp plus 1 tsp (20 g) butter, softened

7 oz (200 g) heavy cream

14 oz (400 g) crème fraîche

11 oz (320 g) cherries, pitted

o Preheat the oven to 350°F (180°C/Th. 6). Brush a 9-inch round baking dish with 1 Tbsp plus 1 tsp (20 g) softened butter and sprinkle with 1.4 oz (40 g) sugar.

o In a large bowl, crack the eggs, add the remaining sugar, and whisk until the mixture has become foamy and pale. Add the flour and both kinds of cream, and mix thoroughly.

o Arrange the unpitted cherries in the baking dish, then pour the batter over them. Bake for about 40 minutes.

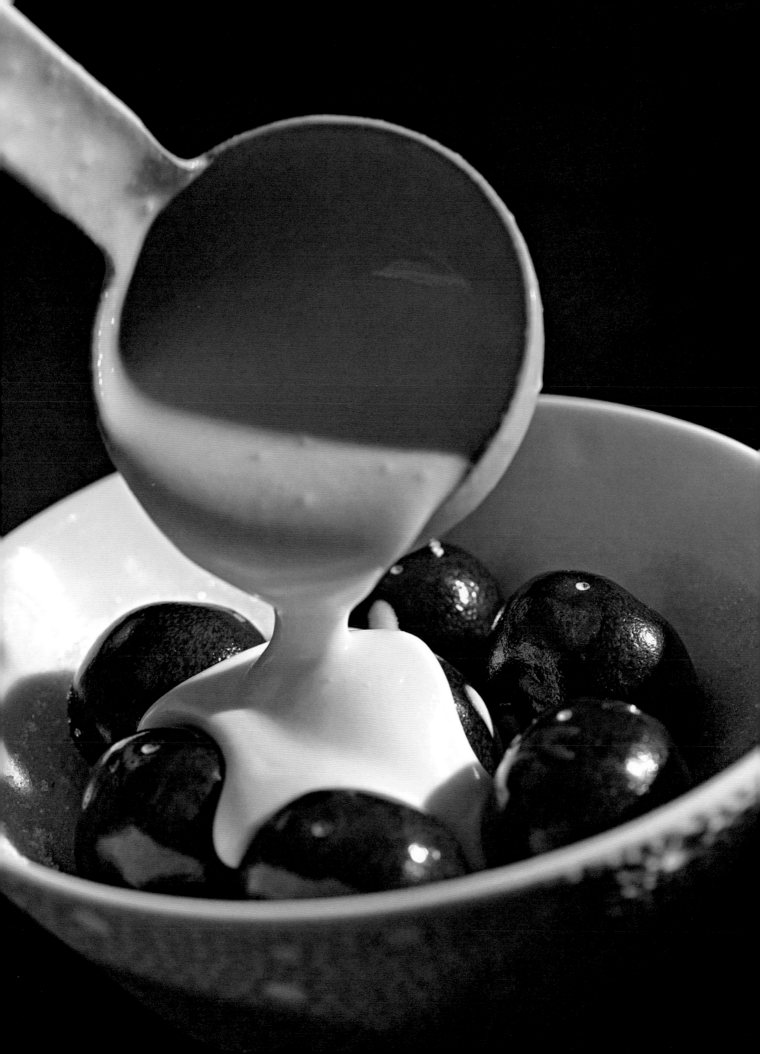

CHAPTER 5
CELEBRATORY DISHES

Have you ever wondered about festive foods?

Why—apart from its rarity and therefore its price—a food gets set aside for exceptional days? Why a few precious dishes are served only during the holidays at the end of the year, and why the simple act of savoring them gives us a feeling of plenitude? Are they so extraordinarily delicious?

Yes, certainly, but the sensation of happiness they produce is also tied to these foods' particular effects on our bodies. Effects that, without our being aware of it, our brains demand, as they have for thousands of years. Thus our body has shaped our tastes. Take as an example Christmas dinner, when a lovely fire crackles in the hearth: We French enjoy goose liver and turkey with chestnuts, finishing almost invariably with the traditional chocolate Yule log. In this case the foods are not at all seasonal and can be obtained all year long, but they warm the body and the heart at the same time. And yet, six months later, when summer comes, who feels like digging in to turkey with chestnuts? Then our bodies, because they have other needs, will have other desires, and will make them known. This does not prevent merrymaking in July: A few shellfish on the beach with a glass of good white wine make for a different seasonal pleasure.

142

For a long time, some of these foods were neglected for reasons of superstition rather than taste. Thus, in the middle of the nineteenth century, in the middle of a long-lasting famine, masses of Irish exiled themselves to a brand-new America instead of trying the strange-looking lobsters so plentiful off their own shores. And at the beginning of the twentieth, many country folk in Perigord gave their pigs the truffles they are so fond of. In those days, except at the tables of a few people of rare privilege, the most sought-after dishes were above all satisfying, even invigorating. It was only when most people could count on getting their daily bread that the table could grow refined for special occasions. Thus the celebratory meal was born.

MYTHICAL CAVIAR

Why is caviar so expensive? How did it become a luxury product that no one can get enough of, not even at the fanciest hotel tables? And yet, it is one of the best gifts you can give a friend who is tired or convalescing, as each sturgeon egg contains the essence of a very large fish-to-be (the largest belugas can reach 16 feet or 5 meters in length), including a terrific reserve of minerals, iron, proteins, fats—especially the polyunsaturated ones—and phospholipids, which contribute to good brain function and stimulate the memory and nervous system functions.

This group of elements in each caviar egg also promotes the function of bone marrow, which produces blood cells, contributes to the suppleness of bones, protecting them from osteoporosis. This helps us understand why at Christmas, when winter's cold exhausts the body and saps its energy, caviar becomes a sought-after dish. Today, sturgeon-fishing in the Caspian Sea is strictly regulated to preserve this endangered species, but farms have been established with success in western Europe (notably France and Italy), enabling undiminished consumption.

Even better news is that the eggs of many other infinitely less expensive fish—salmon, for example—have about the same virtues as caviar and can worthily replace it.

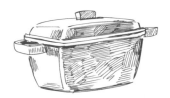

DREAMY TRUFFLES

The black winter truffle (tuber melanosporum) is often called the "black diamond," and the white Alba truffle (tuber magnatum) the "white diamond." It's a question of rarity, for even in the places they originate from (the Perigord and especially the Vaucluse for the former, Italian Piedmont for the latter), they remain prized anomalies.

The production of the French black truffle, originally a wild mushroom, has been divided by five or eight (depending on the year) in a century. Truffle farms have been established, but with very mixed results. Besides the fact that the tuber melanosporum is very capricious (its origins still hold plenty of mysteries, even for scientists), these artificial plantations are coveted and often plundered.

But if the winter truffle is called the black diamond, it is also because it is a real gem for our bodies. Terrifically rich in easily absorbed proteins, it is a pure energy source, without any fat. It is also rich in iron and in sulfur, minerals indispensable for the blood, the nervous system, and the bones. Finally, it also contains a lot of vitamins: B2, B3, B5, D, and K.

GOOSE AND DUCK LIVER

In Roman times it had been observed that migratory birds, notably geese, naturally gorged themselves before undertaking their long voyage. This may have allowed them to avoid the necessity of touching down in sometimes unfriendly regions to refuel, and even allowed them to cross seas. What chef in Tuscany or Lombardy first thought to promote this habit on a farm? History may not remember his name, but it has not forgotten his recipe.

Today, although there are still farms in Perigord, Alsace, and the southwest, France's national production cannot keep up with demand, and livers must be imported from eastern countries to be prepared and cooked in France.

Two kinds of palmipeds are sought after and selected for making liver:

Gray goose, which produces livers of 1½ to 1¾ pounds (700 to 800 g) with a very delicate mouthfeel, but which can be uncontrollable and sensitive as it is raised;

Moulard duck: Its liver rarely exceeds 1 pound (500 g), and reduces more during cooking, and its flavors are certainly more pronounced and less delicate, explaining its lower price.

144

Goose or duck liver is a delicate dish that demands delicate treatment. The more careful you are to handle it gently, the less it will melt away during cooking. You must be careful, then, to work slowly and with patience.

It is unnecessary to add truffles, sauternes, or armagnac to a terrine of fresh duck liver, as these ingredients will only hide the pure and nuanced flavors that make the product great. The sugar traditionally added to the seasoning gives the liver an attractive color when it is cooked.

Temperature is a most important factor: Duck liver is fragile and must cook at a very low temperature, otherwise it will irremediably lose volume. Undercooked, a duck liver has a granular look that is very off-putting. Overcooked, it will shrink greatly.

Never rush the cooling of a hot terrine. It is important to leave it alone and to wait patiently as it comes up to room temperature before placing it in the refrigerator.

Choose a good liver: It should be rather pale, pinkish ivory, and its texture rich, at once tender and creamy.

Preparation: It can be prepared many ways (thinly sliced and pan-fried, mi-cuit, preserved, even broiled), but the most traditional method is also the most common: cooking it in a porcelain terrine after very thoroughly cleaning it of veins and properly seasoning it. Once cool, it is sliced and served with lightly toasted country bread.

Precaution: You must be sure to follow your recipe to the letter. If it was developed for goose liver, you might be tempted to use duck liver, a bit less costly, but a deceptive economy: The result will not be at all the same!

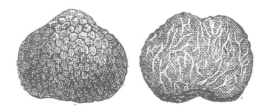

A way of cooking that I like a lot, and which remains unexpected for foie gras: steam.

STEAMED FOIE GRAS

SERVES 4

1 raw foie gras, about 1 lb (450 g)
Salt and freshly ground black pepper
Plastic wrap

Steamer (such as a couscoussier, double boiler,
 or electric steamer, but not a pressure cooker)
Paper towels

◦ Cut the foie gras in ½ inch slices, season with salt and pepper, and wrap each slice in plastic wrap to make individual packets. Bring the water in the steamer to a boil, and steam the foie gras slices 5 to 7 minutes.

◦ Test the cooking by pressing on the foie gras with a finger: If it is lightly firm but still supple, it is perfect. If it is completely firm under the finger, it is already overcooked.

◦ Drain the packets on paper towels and cut off the ends of the plastic wrap to remove the foie gras more easily.

◦ You may serve foie gras with a lot of vegetables, but the ideal is to counter it with a bit of acidity. I often offer lentils, which you may season with a bit of vinegar. Once these are spread in an even layer in a dish, lay the foie gras slices on top and sprinkle with coarse salt, pepper, and chives.

Besides the harmony of the colors (especially if the plate is white), I take pleasure in the seemingly contradictory pairing of very aristocratic foie gras and very rustic lentils.

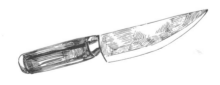

LOBSTER

With its prehistoric looks, lobster is a very old treat; it can be found on mosaics from the Roman era. In the eighteenth century, however, the governor of Massachusetts enacted a singular decree in his territory:

This crustacean was not to be served more than twice a week to prisoners, slaves, and servants, because that would be too harsh a punishment! This decapod with enormous claws—these are the principal visual distinction between it and the rock lobster (*langouste*)—was then so abundant on the east coast of the United States that after big storms covered the beaches with them, they were used as fertilizer in field and gardens. Things have changed quite a bit since then.

A lover of cold seas and rocky beds, the lobster has also colonized European coasts with a slightly different species: the blue lobster or Breton lobster, which the most knowledgeable gastronomes say is much tastier and more tender than its Yankee cousin. Also a victim or overfishing and coastal pollution, it has become more and more rare. For about a decade, thanks to thoughtful and organized management of resources, it has been in the process of reestablishing itself along the rocky Atlantic coast.

From a nutritional point of view, lobster is naturally rich in potassium and zinc, concentrated especially in the tail (which is really its abdomen). On the other hand, this predator accumulates and concentrates in its liver—delicious because it is so aromatic—every pollutant in its path: heavy metals, PCBs (polychlorinated biphenyl), phycotoxins, etc. But not to worry, the organization Health Canada—this country leads world production—recommends that we not consume more than two lobster livers a day.

Often considered the finest of the crustaceans, lobster can be cooked many ways: simply broiled, baked, poached in court bouillon, steamed, eaten hot or cold, and even presented raw in sashimi. There are also many suitable accompaniments: mayonnaise, obviously, or sauces made with cider, wine, or champagne. And its shell and liver serve to make a stock for bisque or fish soup.

Lobsters bought alive must be cooked as quickly as possible. If you are forced to make them wait (two days at most), they should be washed in cold water, wrapped in a damp cloth, and refrigerated. When you take them out, wash them again the same way before cooking.

AMÉRICAIN OR ARMORICAIN?

It happened in Paris, near the grands boulevards, a little after 1860. Pierre Fraysse, a cook from Sète, brought enough dollars back from the United States to open, not far from the Opéra, his own place, which he baptized Peter's. His talent soon won him an enviable reputation, while his sign attracted many of the new tourists coming over from the new world on the new steam-powered ocean liners.

One fine night, late, four Yankees showed up at Peter's. People were talking (in English!), people were getting along, people were drinking, but the pantry was almost empty. Nothing but three or four lobsters, and of course the ingredients a true Sétoise never runs out of: tomatoes, onions, olive oil, aromatic herbs, white wine from Provence, and a few heads of garlic. Pierre Fraysse disappeared into the kitchen for half an hour, and came out with an improvised masterpiece, which delighted his guests.

It came time to name this creation. Generous, as they know how to be in Sète, Pierre Fraysse dedicated his recipe to his customers that evening. Thus was born "américain" lobster (*homard à l'américain*).

SPICED LOBSTER

SERVES 4

2 lobsters, 1⅓ to 1½ lb (600 to 700 g) each

3 tomatoes, peeled, seeded, and diced

2 cloves garlic

1 onion, peeled and finely chopped

4 shallots, peeled and finely chopped

1 bouquet garni (1 sprig fresh thyme
 and 3 stems flat-leaf parsley)

1 Tbsp parsley, minced

1½ Tbsp tarragon, minced

1 dash cayenne pepper

¼ cup plus 2 Tbsp (10 cl) cognac

2 Tbsp tomato paste

2 cups (50 cl) dry white wine (Muscadet)

3 Tbsp (5 cl) olive oil

2 cups (50 cl) fish stock

7 Tbsp plus 1 tsp (110 g) butter

1 big pinch turmeric

1 small branch rosemary

Coarse salt

Salt and freshly ground black pepper

⦾ Rinse the lobsters. In a pot, bring to a boil about 2 quarts (2 liters) of water with 1 Tbsp of coarse salt. When it bubbles, boil the lobsters for 2 minutes, then drain them.

⦾ Remove the claws and the head from the body. Slice the body in half lengthwise. Remove the gravel sac. Put the coral and the creamy parts in a bowl. Cut each tail into four sections. Crack the claws' shells to make it easier to remove the meat after cooking.

⦾ Use the palm of your hand to lightly crush the unpeeled garlic cloves. Peel and finely chop the onion and shallots. Rinse the components of the bouquet garni and tie them together. Wash and chop the tarragon and parsley to obtain 1 Tbsp parsley and 1½ Tbsp of tarragon.

⦾ In a large pot, heat 1 Tbsp butter, add the onion, shallots, garlic, and a pinch of salt. Cook over low heat for 3 minutes without allowing the vegetables to color, stirring constantly with a wooden spatula. Set aside.

⦾ In another large pot, heat 6 Tbsp olive oil for 2 minutes. Season each section of lobster with a small pinch of salt and a dash of black pepper. When the oil is very hot, place the lobster sections in it with the bodies and the claws. Cook for about 3 minutes, turning the pieces constantly, until the shells are very red.

⦾ Add the diced tomato, onion, shallots, garlic, bouquet garni, 1 Tbsp minced tarragon, and a dash of Cayenne pepper. Pour 2 Tbsp cognac over all. Let it bubble and cook away, then add the white wine. Stir thoroughly, add fish stock, 2 Tbsp tomato paste, generous pinch of turmeric, and the rosemary branch. Season with 1 scant tsp salt and a pinch of pepper. Bring quickly to a boil. Cover the pot, lower the heat, and simmer very gently about 8 minutes, stirring once or twice.

⦾ Remove the lobster pieces to a dish and keep them hot. Mash the coral and creamy parts with a fork and mix in 6 Tbsp plus 2 tsp (100 g) butter.

⦾ Remove the bouquet garni from the pot and whisk in the butter-coral mixture to make a sauce. When it bubbles, remove from heat, taste, season with salt and pepper if necessary. Pour the sauce over the lobster pieces and sprinkle with the remaining chopped fresh tarragon. Serve immediately.

CLOSE UP ON SEA SCALLOPS

Sea scallops are appreciated in almost every country of the world with coastal access. French cuisine certainly makes good use of this little shelled treasure, but it is also often used in Japan and in China. It must be said that this seafood is delicious and has very interesting nutritive qualities: numerous good-quality proteins, vitamins, and minerals that are excellent for the skin's health and radiance!

Do not confuse them with bay scallops (noix de pétoncle), much less expensive but much less tasty. The two halves of a bay scallop's shell are equally rounded out, while the sea scallop has a sort of flat cover over a hollowed-out bottom shell.

A little practical advice: To open a sea scallop, slip the tip of a small knife between the two shells at the base of the curve, then move it all the way around the curve to the other side. Then open the shell, cut the scallop out at its base and rinse under running water.

SALAD OF SEA SCALLOPS AND CHANTERELLES

8 large sea scallops

1 small head treviso radicchio, leaves separated, washed, and dried (or an equivalent amount of mâche)

1 endive, leaves separated, washed, and drained

For the marinade:

2 Tbsp olive oil

3-4 threads saffron

Salt and freshly ground white pepper

For the vinaigrette:

4 Tbsp peanut oil

Apple cider vinegar

Salt and freshly ground white pepper

For the mushrooms:

Olive oil

1 small white onion, sliced into thin rounds

1 small fennel bulb, sliced into thin rounds

4¼ oz (120 g) chanterelles
(or white button mushrooms)

● Rinse the scallops under cold running water and dry with paper towels. Steady each scallop on your work surface by pressing gently on it with your palm and use a thin, very sharp knife to slice it horizontally into 4 rounds, beginning at the bottom. Arrange the rounds side by side on a large dish.

● In a bowl, mix 2 Tbsp olive oil, a pinch of saffron, a pinch of pepper, and a pinch of salt. Use a brush to swab the scallop slices on both sides with this mixture. Cover the dish of scallops with plastic wrap and refrigerate.

● In a bowl, pour 2 Tbsp apple cider vinegar and a pinch of salt. Whisk in 4 Tbsp peanut oil. Season with pepper.

● Stack the endive leaves atop each other and cut lengthwise into slivers ¼ inch (½ cm) wide. Put them in a large bowl, drizzle with half the vinaigrette, and toss well. Add the treviso or mâche, drizzle with the remaining vinaigrette, and toss well.

● Clean the mushrooms with paper towels. For white button mushrooms, cut off the base of the stem, rinse, pat dry, and chop roughly into thin slices. For chanterelles, quarter the larger ones lengthwise.

● In a saucepan, combine 3 Tbsp olive oil, the onion, and the fennel. Heat over medium heat and cook 2 to 3 minutes, until the onion is tender and transparent. Add the mushrooms and continue to cook 3 to 4 minutes over medium-high heat. Any liquid released by the vegetables should cook away. Taste and season with salt and pepper.

● Remove the scallops from the refrigerator and arrange them around the perimeter of the salad. Transfer the mushrooms to the center of the salad and sprinkle with a pinch of fleur de sel.

SEA SCALLOPS WITH BLUE POPPYSEEDS

SERVES 4

✳ FOR THE YUZU SAUCE:

1½ Tbsp (25 ml) yuzu juice (*this citrus fruit, resembling the sour grapefruit and the mandarin, can be found in Asian markets and on the Internet*)

Pinch of sugar

1 tsp egg white

Salt and freshly ground black pepper

5 Tbsp (7 cl) extra virgin olive oil

- Stir together the yuzu juice, sugar, and egg white, season with salt and pepper.
- Emulsify with the olive oil.
- This sauce is also marvelous with carpaccio of fish such as sea bream.

✳ FOR THE CROUTONS:

1 oz (30 g) good-quality white sandwich bread, diced

4 Tbsp (60 g) butter

1 clove garlic

- Cut the bread into small dice or medallions. Heat the butter in a skillet and cook the garlic and diced bread until the bread is golden. Remove from heat, discard the garlic, and drain the croutons on paper towels.
- These croutons keep very well in a sealed container. With drinks, serve them with a bit of salted butter. They also make a welcome addition to a salad or soup.

✳ FOR THE SCALLOP CARPACCIO AND PLATING:

8 sea scallops

1 tsp olive oil

1 Tbsp blue poppyseeds

1 Tbsp chives, minced

1 scant tsp pink peppercorns

Fleur de sel de Guérande

Freshly ground black pepper

1.4 oz (40 g) bottarga, sliced very thin (*this "Mediterranean caviar" can be found in fine grocery stores or on the Internet*)

A few leaves of arugula

Sprinkle of yuzu zest

- Rinse the scallops in a trickle of running water, then dry them with paper towels. Slice into slivers and place on lightly oiled plastic wrap.
- Arrange the scallop slivers on each plate and, using a brush, swab with yuzu sauce. Sprinkle with blue poppyseeds, minced chives, pink peppercorns, and fleur de sel. Top with a grinding of pepper.
- Finally, add the thin slices of bottarga, the croutons, a few small arugula leaves, and the yuzu zest.

PRESERVED DUCK FOIE GRAS

SERVES 4

1 duck liver, about 11 oz (300 g) (large lobe)
2 lb (1 kg) goose fat
1 pinch crushed black pepper

1 pinch fleur de sel de Guérande
1 pinch superfine sugar

○ Place the liver lobe on a piece of plastic wrap and season on both sides with fleur de sel, crushed black pepper, and a pinch of sugar. Wrap and refrigerate for at least 3 hours.

○ Put 2 lb (1 kg) goose fat in a large pot and heat to 150°F (65°C). Lower the liver into the fat and poach for 1 hour at 130°F (55°C).

○ Remove the pot from the heat and allow the liver to cool to room temperature in the fat. Then transfer the liver to a container, being sure to cover it completely with the fat.

○ Cover with plastic wrap and refrigerate for 15 days.

○ Serve with toasted country bread, fleur de sel, and freshly ground black pepper.

FOIE GRAS SLIDERS

SERVES 4

8 small (.5 oz/17 g) brioche buns
 with sesame seeds
8 small (1.5 oz/40 g) patties beef ground from
 hanger steak, shaped to fit the buns
8 small (.5 oz/15 g each) slices foie gras
1 Tbsp julienne of red bell pepper
1 Tbsp julienne of green bell pepper

1 Tbsp julienne of yellow bell pepper
4 Tbsp sweet-and-sour sauce
2 handfuls watercress shoots
1 Tbsp vinaigrette
2 spring onions sliced into thin rounds
1 Tbsp olive oil
Fine salt, freshly ground black pepper

○ Slice the buns in half at the midline. Under the broiler, toast the inside faces of the split buns.

○ In a small skillet, quickly cook the julienned peppers with a tablespoon of olive oil. Season with fine salt and freshly ground black pepper; set aside and keep warm.

○ Season the foie gras slices and, in another skillet, sear them on both sides. Set aside and keep warm.

○ Season the beef patties and, in the same skillet, with the rendered foie gras fat, quickly pan-fry them. Set aside and keep warm.

○ In a large bowl, toss the watercress shoots with the vinaigrette.

○ To plate, distribute the julienned bell peppers among half the buns and drizzle with sweet-and-sour sauce. Top with the beef patties, and top these with the foie gras, watercress, and onion rounds.

○ Grind some black pepper over the sliders before placing the top buns.

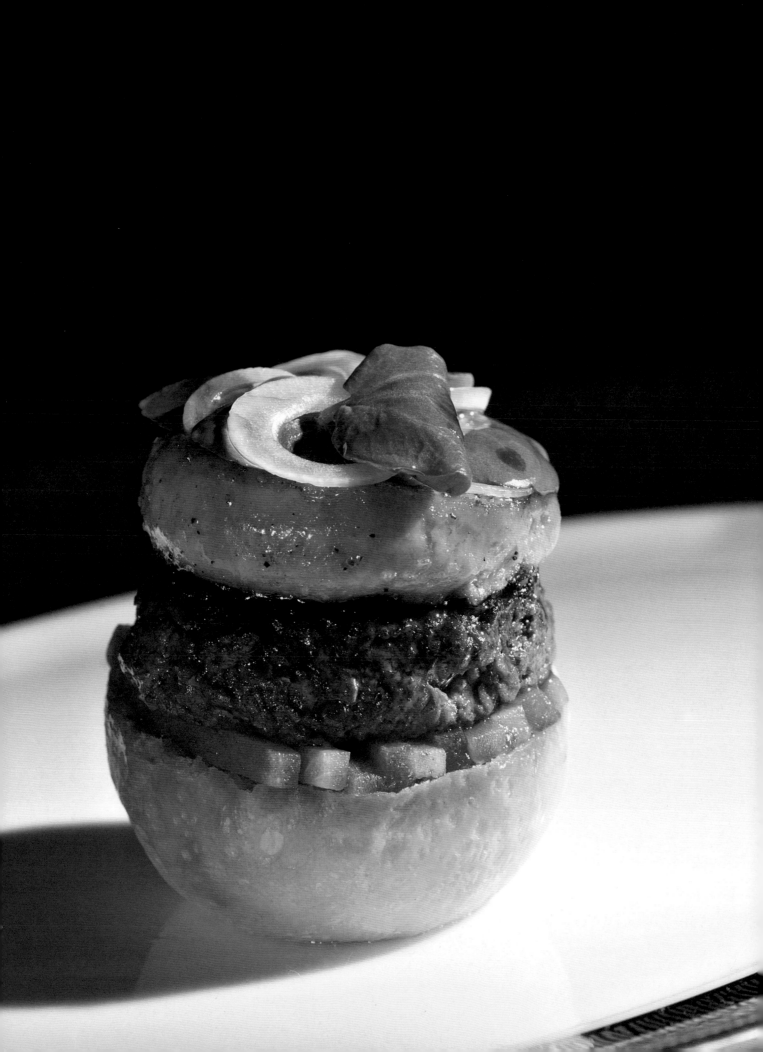

FOIE GRAS PUDDINGS

SERVES 4

2¼ oz (65 g) duck foie gras, raw
1½ oz (45 g) duck foie gras, cooked
1 cup (¼ liter) red port
10½ oz (300 g) cream

1.4 oz (40 g) parmesan cheese, diced
1 egg
Salt and freshly ground black pepper

○ Put both kinds of foie gras into a blender, then carefully pour in 6⅓ oz (180 g) of cream, heated. Blend, add 1 whole egg, blend again; season with salt and pepper.

○ Pour this creamy mixture into 4 glass ramekins. Place the ramekins in a bain-marie or water bath: Arrange the ramekins in a baking dish, and pour into the baking dish enough simmering water to come halfway up the sides of the ramekins. Cover and bake at 250°F (120°C/Th. 4) for 30 minutes. Be very careful to not get any water in the ramekins.

○ Reduce the red port until you have about 3 Tbsp (3 cl).

○ Rinse the inside of a saucepan with water to prevent sticking. Pour in the remaining cream and the diced parmesan cheese. Bring to a simmer and cook 10 minutes over low heat. Put this parmesan cream through a small strainer without pressing the cheese too much.

○ Swab the top of each ramekin of foie gras with about 1 tsp of port reduction, and pepper lightly. Top each ramekin with parmesan cream and serve immediately.

CHESTNUT VELOUTÉ WITH FOIE GRAS

SERVES 4

4 slices duck foie gras, about 1.8 oz (50 g) each

For the chestnut velouté:
6 oz (175 g) chestnuts, peeled
¾ oz (20 g) shallots, peeled and sliced thin
1 clove garlic, peeled and chopped
½ oz (15 g) celery stalk, peeled and
　　cut into small sticks
1 Tbsp plus 1 tsp (20 g) butter

2½ tsp (1.2 cl) cognac
2 cups (50 cl) chicken broth,
　　preferably homemade
⅓ cup (7.5 cl) crème fraîche
Salt and freshly ground black pepper

For plating:
2 celery leaves, cut in chiffonade
1.4 oz (40 g) smoked bacon, cooked and crumbled

○ Peel and thinly slice the shallots; peel and chop the garlic; peel the celery stalk and cut it into small sticks. In a saucepan, melt the butter and sweat the vegetables together for about 8 minutes. Add the chestnuts and sweat 3 to 4 minutes more, add the cognac, and cook a few minutes longer.

○ In a separate saucepan, heat the chicken broth, then add it to the vegetables, add the crème fraîche, and cook 20 minutes more. Discard the celery. Pour the rest of the mixture into a blender or food processor, blend until smooth, and season with salt and pepper. At this stage of the recipe, you have already made a delicious chestnut velouté (tip: it can also be eaten as is on its own).

○ Heat the chestnut velouté and pour it into a shallow serving bowl. Garnish with smoked bacon crumbles and celery leaf chiffonade.

○ Heat a nonstick skillet and sear the foie gras slices for just a few seconds; drain on paper towels and arrange atop the velouté at the last minute.

○ You may use slices of frozen foie gras and the recipe will work just as well.

Truly exquisite, this sauce will also enhance many other dishes, including the most simple—for example, a nice dish of fresh pasta!

CREAMY CAVIAR SAUCE

SERVES 4

1.8 oz (50 g) caviar
¾ cup (20 cl) cream

¼ cup plus 2 Tbsp (10 cl) mussel liquor
Salt, freshly ground black pepper

○ In a saucepan, bring the cream to a boil, add the mussel liquor and season with salt and pepper. Remove from heat and gently stir in the caviar.

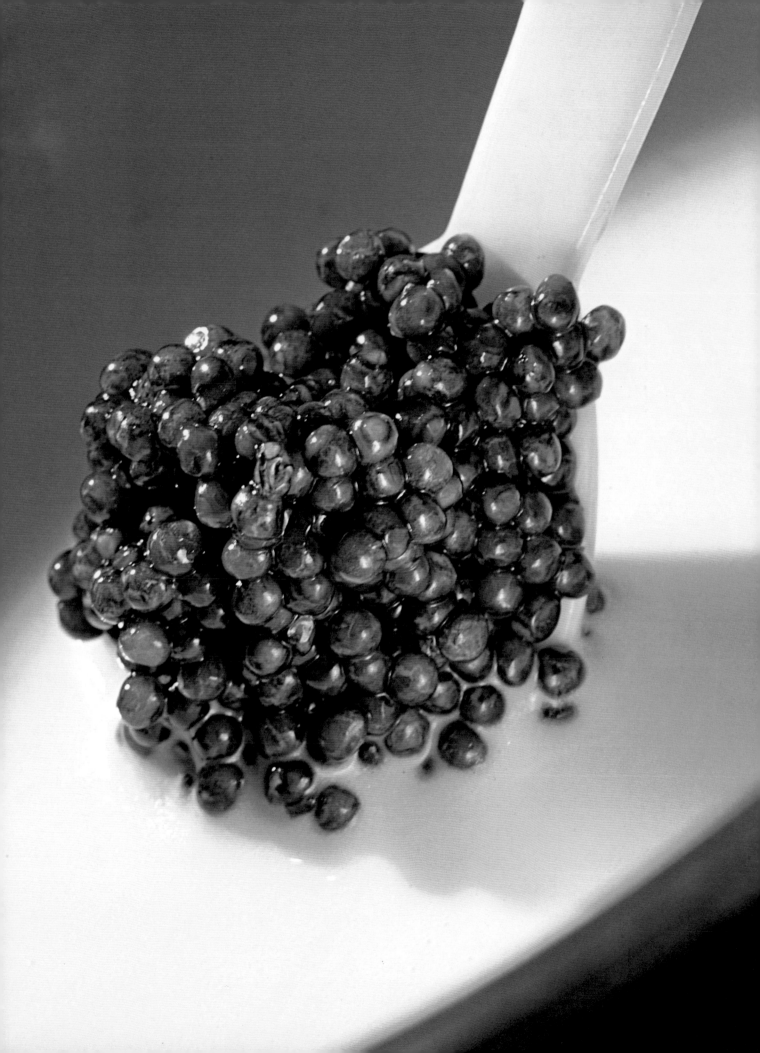

SLIVERED SEA SCALLOPS WITH CAVIAR

SERVES 4

12 sea scallops
A little softened butter
¼ cup plus 2 Tbsp (10 cl) mussel liquor
¾ cup (20 cl) cream
1 Tbsp lemon juice
2½ oz (75 g) caviar

4 chives, minced
Zest of ¼ lemon
1 pinch Guérande fleur de sel
1 pinch crushed white pepper
Salt and pepper (optional)

- Preheat the oven to 350°F (180°C).
- Cut each scallop into 4 very thin slices. On a lightly buttered baking tray, place 24 of the scallop slices and put about ½ tsp caviar atop each, then top them with the remaining scallop slices, to make little sandwiches. Butter the tops.
- In a saucepan, bring the mussel liquor to a boil and reduce by half. Add the cream and bring to a boil. Remove from heat, add the lemon juice, and gently incorporate the caviar. Adjust seasoning if necessary.
- Bake the scallop and caviar sandwiches for 2 minutes. When they come out of the oven, swab them with the creamy caviar sauce. Top each scallop sandwich with 2 flakes of Guérande fleur de sel, 2 bits of crushed white pepper, chives, and lemon zest.

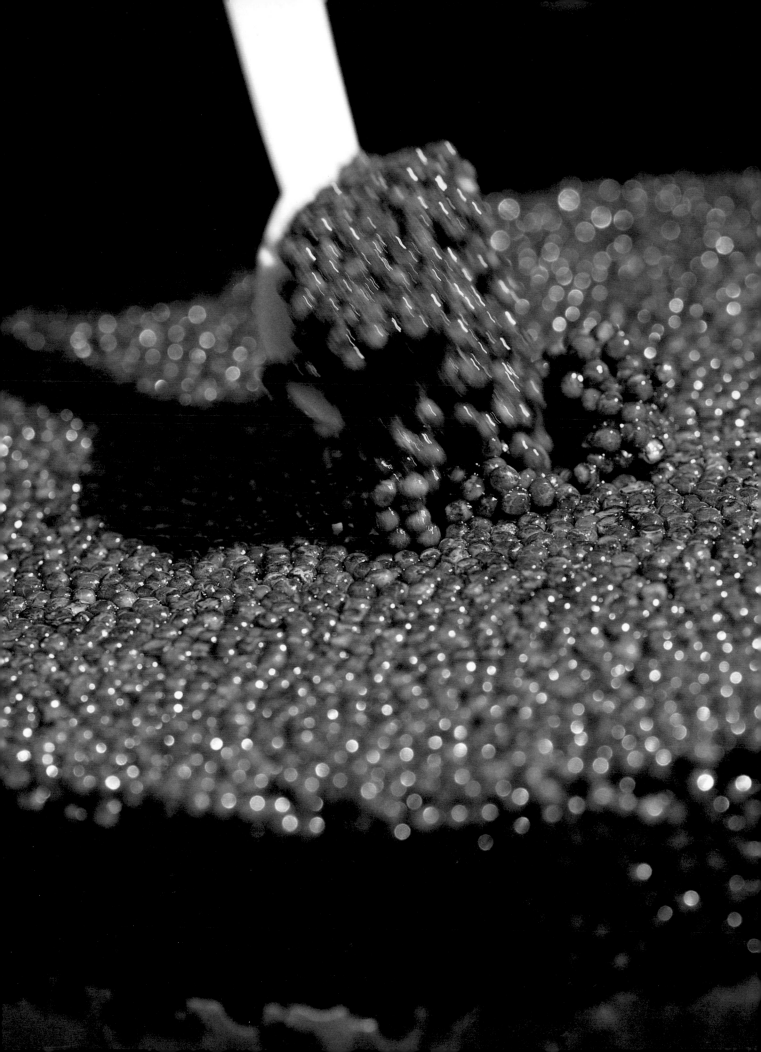

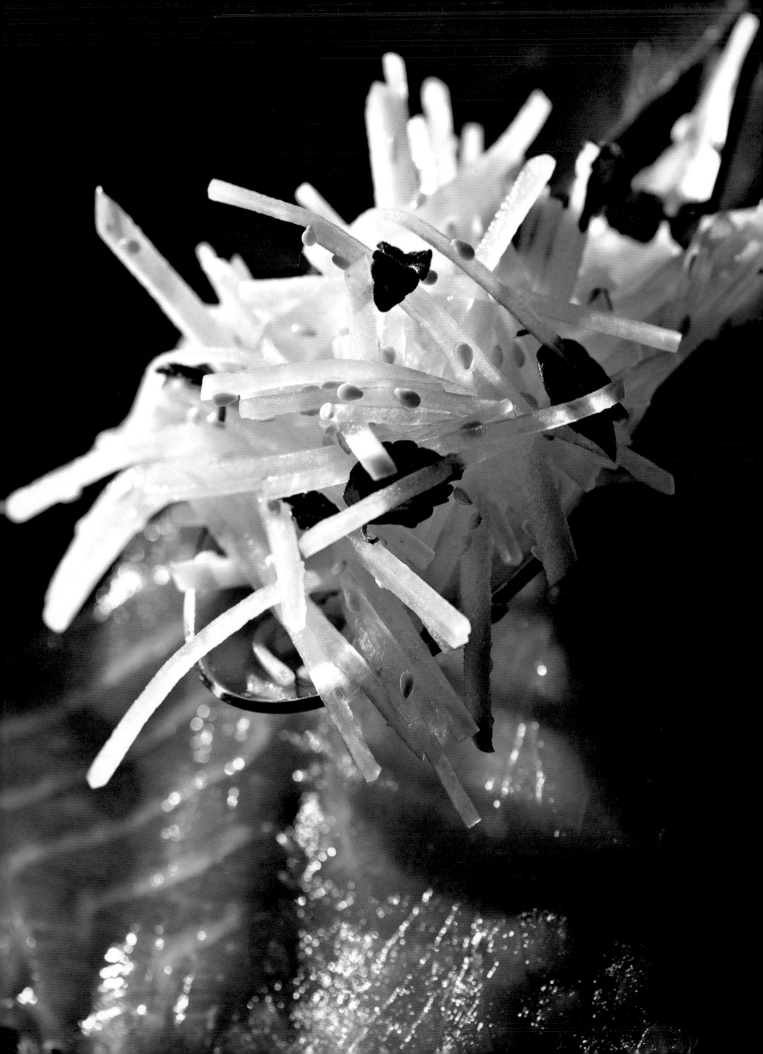

SMOKED SALMON WITH DAIKON RADISH

SERVES 4

8 oz (250 g) smoked salmon, sliced very thin

2.8 oz (80 g) daikon radish (or, if unavailable, black radish), julienned, soaked, and drained

½ white onion, peeled and sliced thin

½ Granny Smith apple, washed, dried, cored, and julienned

1 generous tsp honey

1 generous pinch toasted white sesame seeds

1 tsp trout roe

1 tsp white wine vinegar

6 tsp sesame oil

4 tsp Japanese soy sauce

4 tsp balsamic vinegar

12 small leaves red shiso, or, if unavailable, basil (purple, if possible)

Fine salt

○ Use a mandoline to julienne the daikon, soak it in cold water for 10 minutes, then drain on paper towels.

○ In a bowl, whisk together the honey, white wine vinegar, 4 tsp sesame oil, soy sauce, and balsamic vinegar, then salt lightly.

○ Carefully wash the green apple, dry it, core it, and julienne it. Peel and thinly slice the onion. In a large bowl, toss the daikon and green apple julienne with the sliced onion, 2 tsp sesame oil, toasted sesame seeds, and trout roe.

○ Distribute the smoked salmon slices among 4 plates and top them with the radish salad. Surround with a ring of vinaigrette and garnish each plate with 3 small red shiso leaves. Serve and eat immediately.

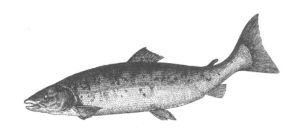

SMOKED SALMON WITH SOY SPROUTS

SERVES 4

8 oz (250 g) soy sprouts
3½ oz (100 g) smoked salmon, diced
¼ red bell pepper, julienned
¼ green bell pepper, julienned
2 medium tomatoes, quartered
8 pink radishes, sliced into thin round
¼ fresh pineapple, cut into thin slices
½ white onion, peeled and sliced thin

For the vinaigrette:
1 Tbsp red wine vinegar
3 Tbsp olive oil
1 dash curry powder
Salt and freshly ground pepper

◦ In a bowl, prepare the vinaigrette by stirring the red wine vinegar together with a pinch of salt and dash of curry powder. Add the olive oil and season with pepper.

◦ Wash all the vegetables and drain. Quarter the tomatoes. Cut the pineapple into thin slices. Slice the radishes into thin rounds. Julienne the bell peppers. Slice the onion thinly.

◦ Thoroughly wash the soy sprouts in cool water, then blanch in boiling water for 1 minute. Remove immediately to an ice-water bath to cool, then drain very thoroughly.

◦ In a salad bowl, add the soy sprouts and all the vegetables, the smoked salmon, the curry vinaigrette, and toss everything gently. Serve right away.

ABOUT THE AUTHORS

JOËL ROBUCHON

World-renowned French chef Joël Robuchon has devoted his culinary art to bringing people health and happiness. Originally from Poitiers, Robuchon was awarded Meilleur Ouvrier de France in 1976, Chef of the Year in 1987, and Chef of the Century in 1990. Today Robuchon holds the most Michelin stars of any chef in the world. In 2014 he will open Atelier de Joël Robuchon in Bangkok and Mumbai, along with a gastronomic restaurant in Bordeaux.

DR. NADIA VOLF

Dr. Nadia Volf, MD, PhD, is a professor, a neuropharmacologist, and an acupuncturist with thirty-five years of experience. She is founder and co-director of the Scientific Acupuncture Department at the Medical University of Paris, France. Currently she continues her research and practice in Paris, both in the university hospital and in her clinic. A member of the American Academy of Medical Acupuncture (AAMA), Dr. Volf has given lectures at Harvard Medical School, George Washington University, and the Pacific College of Oriental Medicine in Chicago. Dr. Volf is the author of several books, translated into twelve languages, as well as a great number of articles published in scientific journals. The aim of her whole life and practice is to combine modern science with traditional wisdom to bring people knowledge of health and longevity.

HARALD GOTTSCHALK

After finishing school, Harald Gottschalk became assistant to the renowned Robert Doisneau and began fulfilling his childhood dream to become a photographer. Gottschalk has had more than sixty solo and collective exhibitions in France and abroad. Parallel to his personal work, Gottschalk collaborates on prestigious projects and publications with international brands.

CREDITS

ACKNOWLEDGMENTS

A great big thank-you from the bottom of my heart to Joël Robuchon,
who helped me to discover the magic and delight of the culinary arts.
Special thanks to Daniel Benharros: This book exists because of his friendship
and his inexhaustible enthusiasm, support, and encouragement.
Thanks also to Christine Benharros for her presence throughout
the creation of this book; to Alain Sarraute for his finesse, understanding,
and artful editing; to Eric Bouchenoire for his magical hands and availability;
to Jacques Abramczyk of Les Halles Mandar in Paris for his generosity and trust;
to Julien Tongourian, Vianney Massot, and Charles Fourreau
for their talent and professionalism.
And thanks especially to Martine and Prosper Assouline
for their friendly confidence, exquisite taste, and editorial artistry.

Joël Robuchon & Nadia Volf

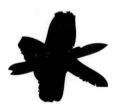

Assouline would like to thank Philippe Pascal,
who first introduced us to Joël Robuchon and Dr. Nadia Volf.
Thanks also to Daniel Benharros for his support throughout this extraordinary work,
to Alain Sarraute for his great contribution to the book,
and to Claude Le-Tohic for his kind assistance.
And a special thanks to Nadia and Joël for trusting Assouline
with such a fascinating project!

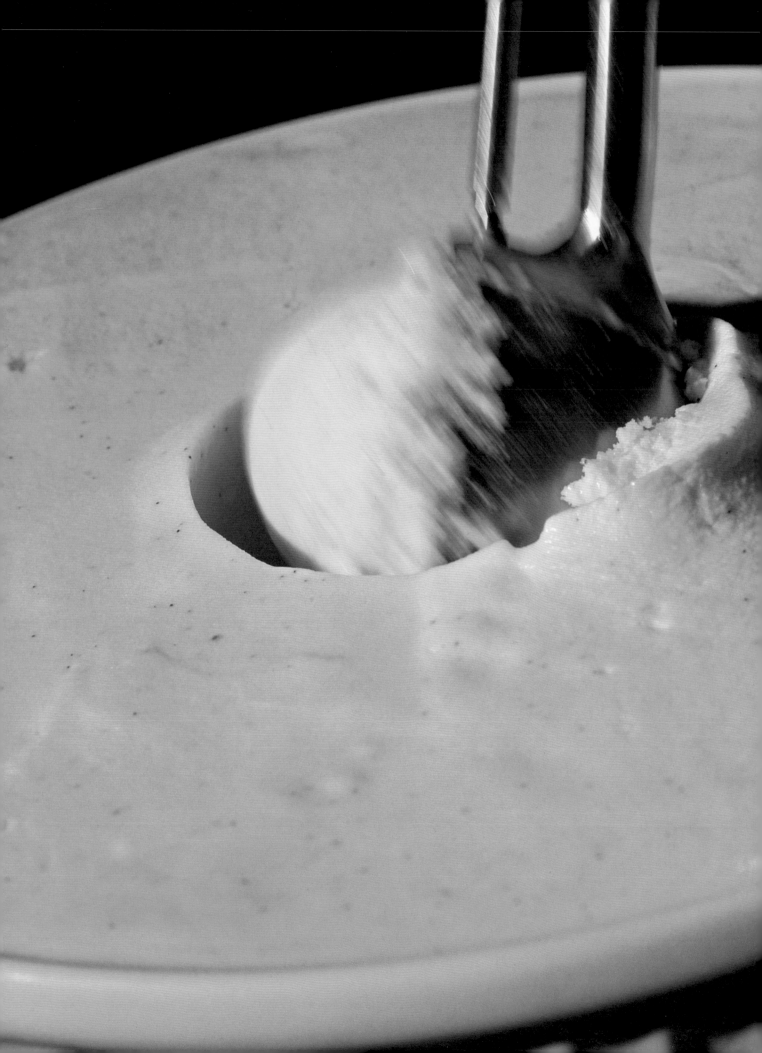

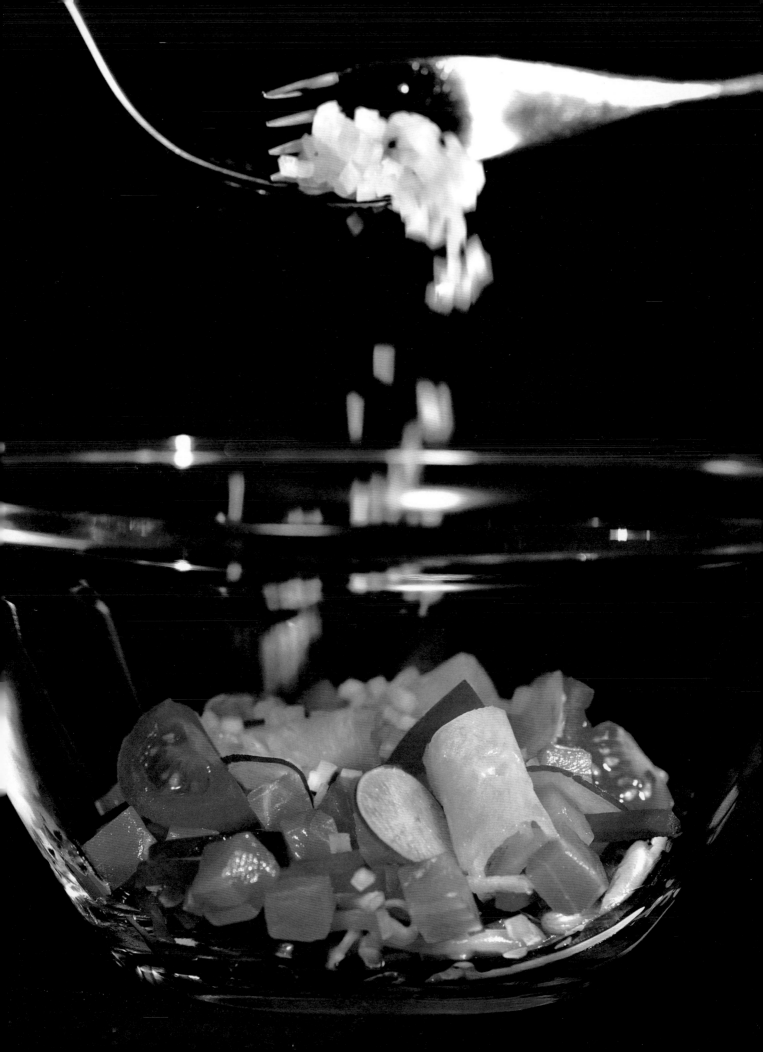